FIRST STEPS
SERIES
Painting Oils

LOUISE DeMORE

NORTH LIGHT BOOKS

Cincinnati, Ohio
www.artistsnetwork.com

Acknowledgments

I want to thank my editors at North Light, especially Greg Albert and Joyce Dolan, for their helpful advice and for being so easy to work with. I also want to thank Peter Mounier for answering my many questions about photography.

Painting Oils. Copyright © 1996 by Louise DeMore. Printed and bound in China. All rights reserved. No part of this book may be reproduced in any form or by any electronic or mechanical means including information storage and retrieval systems without permission in writing from the publisher, except by a reviewer, who may quote brief passages in a review. Published by North Light Books, an imprint of F+W Publications, Inc., 4700 East Galbraith Road, Cincinnati, Ohio 45236. (800) 289-0963. First edition.

Other fine North Light Books are available from your local bookstore, art supply store or direct from the publisher.

10 09 08 07 06 8 7 6 5 4

Library of Congress Cataloging-in-Publication Data

DeMore, Louise.
 Painting oils / Louise DeMore.
 p. cm.—(First steps series)
 Includes bibliographical references and index.
 ISBN-13: 978-0-89134-676-0 (alk. paper)
 ISBN-10: 0-89134-676-7 (alk. paper)
 1. Painting—Technique. I. Title. Series: First steps series (Cincinnati, Ohio)
ND1473.D46 1996
751.45—dc20 96-247
 CIP

Edited by Joyce Dolan
Designed by Brian Roeth
Cover photography by Pamela Monfort Braun/Bronze Photography

F+W PUBLICATIONS, INC.

About the Author

After completing her bachelor's degree in mathematics from UCLA, Louise DeMore returned to the study of art at UCLA, Art Center College of Design and with private teachers, including the master teacher, Sergei Bongart.

DeMore is a signature member of several prestigious art associations. Her award-winning paintings hang in many private and corporate collections.

DeMore has taught classes, workshops and given demonstrations for over fifteen years. She lives with her husband in California.

METRIC CONVERSION CHART		
TO CONVERT	**TO**	**MULTIPLY BY**
Inches	Centimeters	2.54
Centimeters	Inches	0.4
Feet	Centimeters	30.5
Centimeters	Feet	0.03
Yards	Meters	0.9
Meters	Yards	1.1
Sq. Inches	Sq. Centimeters	6.45
Sq. Centimeters	Sq. Inches	0.16
Sq. Feet	Sq. Meters	0.09
Sq. Meters	Sq. Feet	10.8
Sq. Yards	Sq. Meters	0.8
Sq. Meters	Sq. Yards	1.2
Pounds	Kilograms	0.45
Kilograms	Pounds	2.2
Ounces	Grams	28.4
Grams	Ounces	0.04

Dedication

This book is dedicated to my husband, Dennis, whose support and
patience helped make it all possible

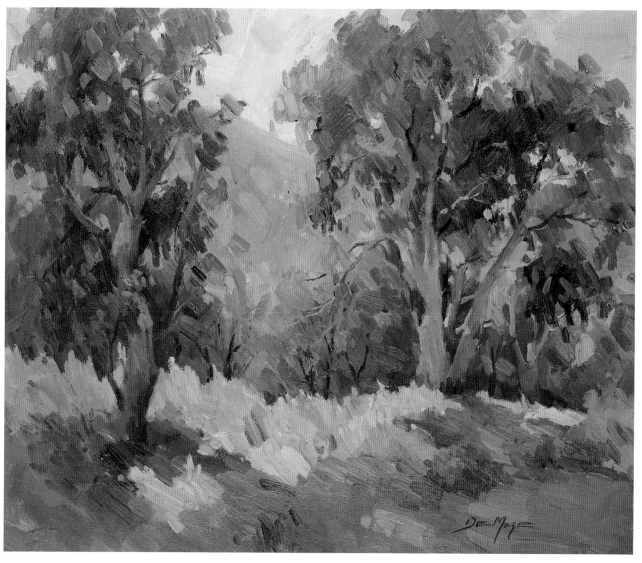

A HANDSOME HOLLOW
20″ × 24″

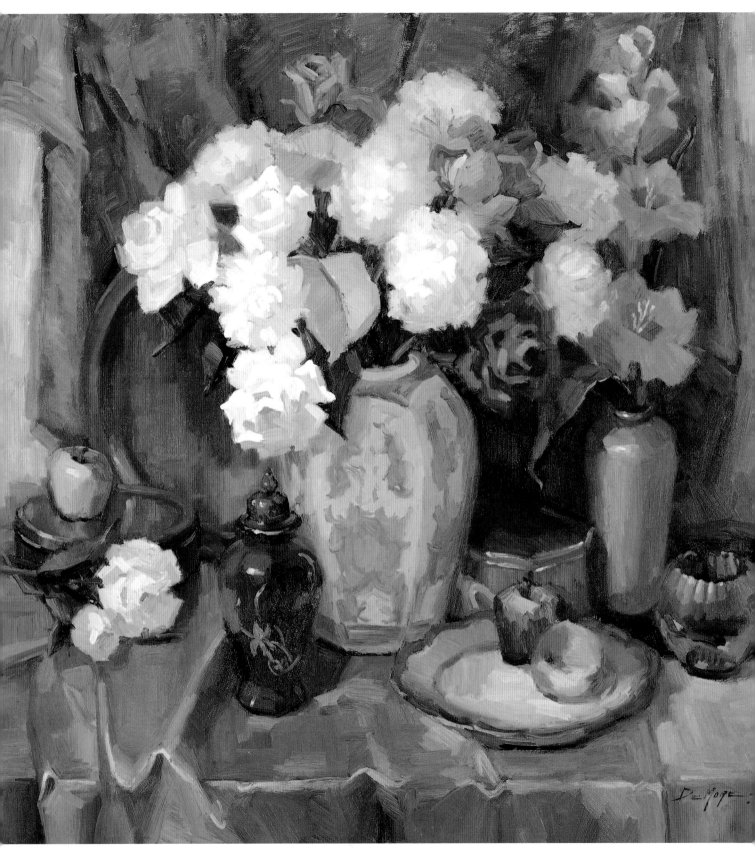

HARMONY IN BLUE
36″ × 36″

Table of Contents

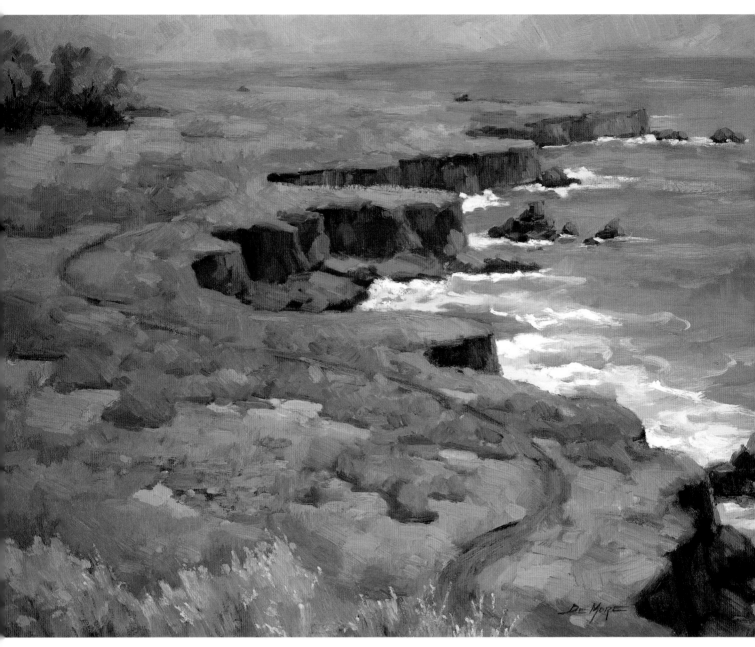

ROAD LESS TRAVELLED
36" × 48"

Introduction

Creating a successful painting is easy and fun. It's just a matter of putting the right color in the right spot! That's what this book is all about.

Oil has long been considered the classic painting medium. It's also the best for the beginner to learn with because:

- ▶ it's easy to use
- ▶ it stays where you put it
- ▶ it doesn't change colors when it dries
- ▶ it's easy to correct mistakes
- ▶ it's easy to mix colors
- ▶ it doesn't dry too fast
- ▶ color mixtures are more predictable than with other mediums

You can pause at any time to:

- ▶ answer the phone
- ▶ change the baby
- ▶ order a pizza (or ask your significant other to do it)
- ▶ study up on how to solve a painting problem

In addition, your masterpieces are easy to frame, and there is no limit to the techniques you can discover as you develop your own style.

Oil is my favorite medium because I love the wonderful feeling I get when I play with rich, juicy, buttery, delicious colors. *Play with paint!* This is what I encourage even the most serious students to do. Let's get started!

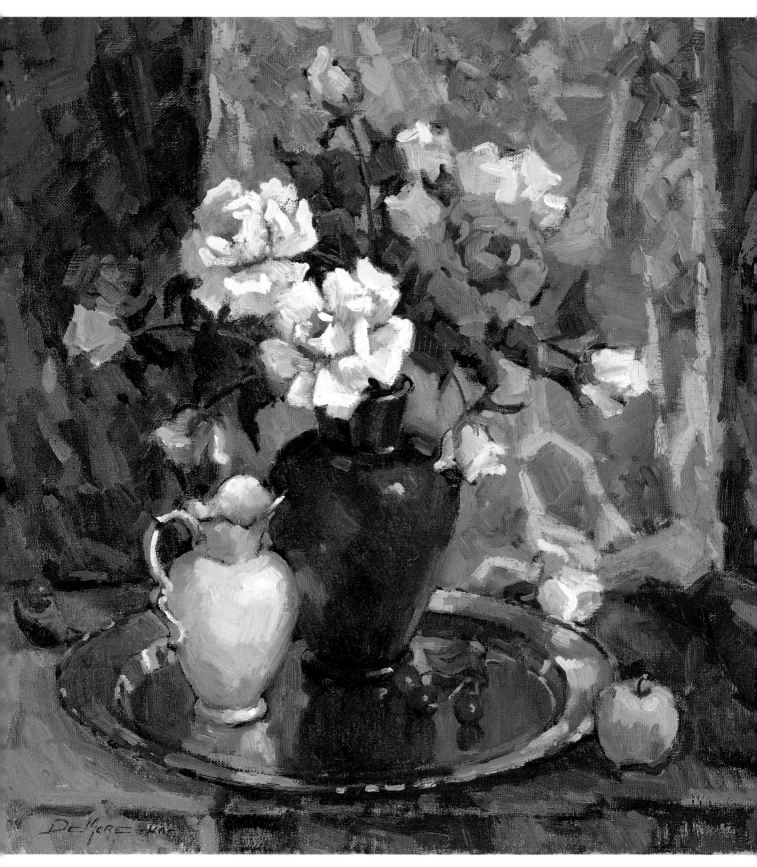

THE BRASS TRAY
30″×30″

GETTING STARTED

Shopping List

Here is a list of supplies you will need to get started painting in oils. You can jot this list down on other paper or make a photocopy of this page and take it shopping with you. I give you more information about each of these items in this chapter.

- ▶ Brushes

 Filberts: one no. 10, two no. 8s, two no. 6s, one no. 4, one no. 2

- ▶ Palette knife
- ▶ A very small painting knife, preferably with a one-inch blade
- ▶ Pre-stretched canvases: several 16″×20″, two 18″×24″ or alternative surfaces listed in this chapter
- ▶ Sturdy easel
- ▶ Light to shine on indoor still lifes
- ▶ Paper towels (very absorbent)
- ▶ Paints—studio-size tubes (37 ml) of

Cadmium Yellow Light	Yellow Ochre
Cadmium Orange	Burnt Sienna
Cadmium Red Light	Cerulean Blue (optional)
Alizarin Crimson	Phthalo Blue (can be in small
French Ultramarine Blue	tube)
Permanent Green Light	Titanium White (large tube—
Ivory Black	150 ml)

- ▶ 18″×24″ white palette, plastic, Formica or a disposable paper pad, if you can find one large enough. This is important! Don't even try to use a palette smaller than 16″×20″.
- ▶ Turpentine or substitute (at least a quart)—if you are very sensitive to turpentine, I recommend Livos Thinner no. 222, available through Eco Design Products, 1365 Rufino Circle, Santa Fe, New Mexico 87501, (505) 438-3448.
- ▶ Small jar of linseed oil and small cup to hold it
- ▶ Can of retouch varnish spray

Brushes

Good brushes are necessary because the brush is your primary tool for creating paintings. The basic types of brushes used with oil are filberts, brights, flats and rounds. I prefer filberts because they are so versatile. The bristles on filberts are flat with a slightly rounded end making them oval shaped. You can make many kinds of strokes with them.

Sometimes I use brights (which have short, flat bristles) for rocks or when I need a sharper edge. Flats have longer bristles and don't allow as much control. Finally, there are rounds, which were the first brushes used in oil painting. Just as the name implies, the bristles form a round shape. You experiment and learn which brushes work best for you.

I use brushes with hog bristles—the stiffer, the better—because hog bristles are easier to control and hold more paint than synthetic bristles. Grumbacher Edgar Degas no. 4229 (which is a filbert) is one of my favorite brushes, but Utrecht makes a good filbert that is less expensive.

The brush size is designated by a number. The exercises in this book can be completed with filberts. You'll need at least one no. 10, two no. 8s, two no. 6s, one no. 4, and one no. 2. It certainly doesn't hurt to have more.

Palette Knives

A large palette knife with a bent blade is necessary for scraping unused paint off your palette. It is also used for scraping large areas on your painting.

Painting Knives

Painting knives are generally trowel shaped and come in many sizes. I usually don't use them for actual painting; however, I find the small ones absolutely essential for scraping off small, unwanted passages or excess paint. The tips of the knives are very fragile. When they are bent, they leave unwanted marks on the surface of your painting, so handle with care. You might even buy them by the dozen like I have to.

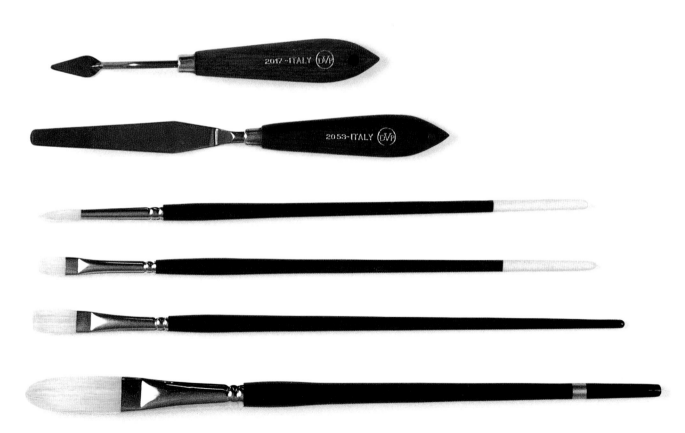

Brushes and Knives. Here are examples of brushes and knives. The top knife is a small painting knife which is essential for scraping off mistakes in small areas. The next knife is a palette knife. The brushes in descending order are a no. 5 round, a no. 5 bright, a no. 6 flat and a no. 10 filbert.

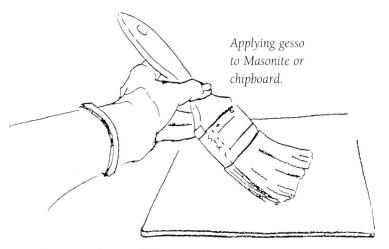

Applying gesso to Masonite or chipboard.

Use the gesso right out of the jar. Apply with an old house painting brush.

1st coat. Allow gesso to dry.

Painting Surfaces

The painting surface is very important. You need a surface that will accept the paint well without absorbing too much pigment. Most artists prefer stretched canvas. You can start by using inexpensive, commercially pre-stretched canvas. Even this can get expensive for beginners just to practice on, so I'll give you some alternatives.

Good results can also be obtained by using untempered Masonite prepared with gesso and three-ply chipboard prepared with gesso. I recommend applying three coats of Liquitex gesso to the Masonite or chipboard plus one coat on the back to prevent warping. You can apply the gesso either thickly or thinly, depending on the texture you want. This will take some experimentation as you continue to paint. In your first paintings, apply thin coats of gesso to gauge the results, and then experiment with different thicknesses as you see fit. The strokes can be applied in alternate directions for each coat or applied randomly for a rougher texture. Allow each coat to dry before applying the next coat.

You can also use museum board, which is actually similar to good-quality mat board for little color sketches. It is absorbent, so the quality of color is different than it would be on other surfaces, but it is good for beginning practice. It is inexpensive, so you can sketch away and experiment more.

Each of these surfaces gives slightly different results. It's fun to try different approaches until you find your favorite. A surface I would never recommend is canvas-covered panel cardboard. Even beginners should avoid it. It absorbs so much pigment you have no color left and actually waste more money on paint.

2nd coat. Alternate strokes. Allow gesso to dry.

3rd coat. Allow gesso to dry.

Random strokes. You can use random strokes for a different texture. Experiment!

Easels

You will need a sturdy easel on which to clamp the canvas and hold it firmly. Then you can be free to paint boldly and scrape fearlessly! There are many kinds of easels and you can have a lot of fun looking for one that's right for you. One that I recommend as versatile, economical and sturdy is the Stanrite aluminum tripod easel. It is lightweight, foldable and fairly sturdy, especially when you place a wooden sketch box in the center. Spend a few dollars more for the slightly heavier model, and you will not be sorry.

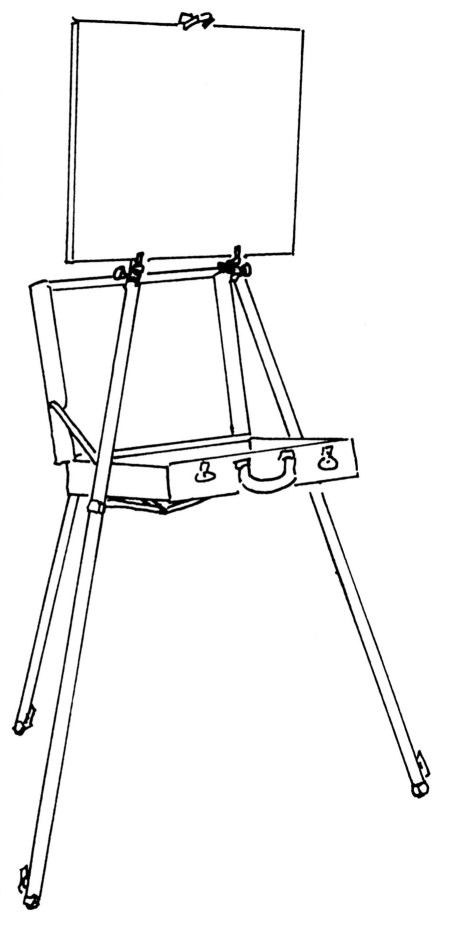

This sketch shows an aluminum tripod folding easel with a sketch box placed in the center.

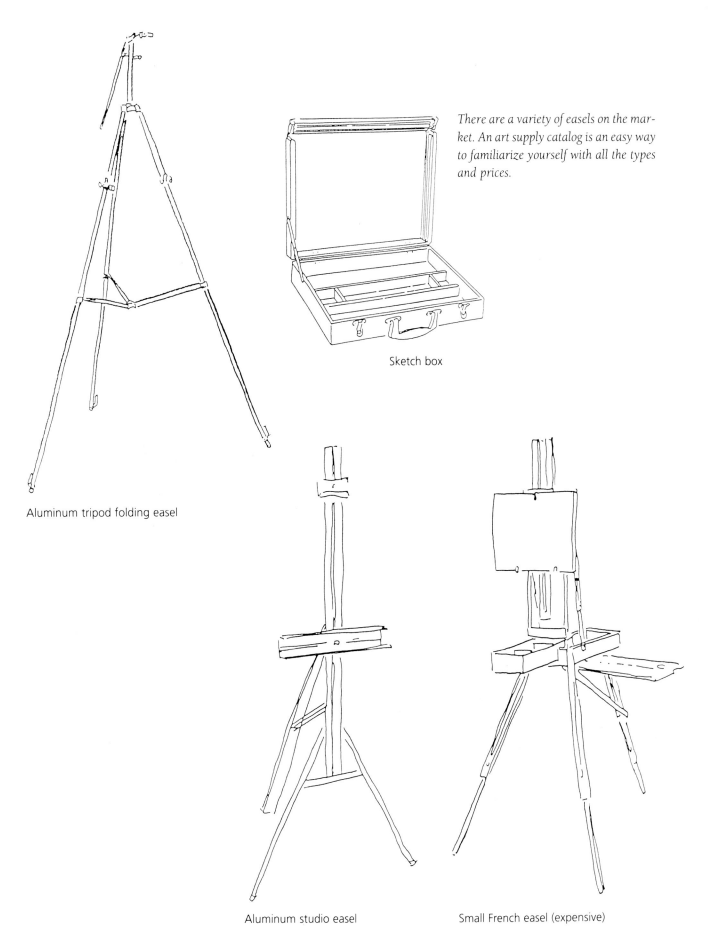

There are a variety of easels on the market. An art supply catalog is an easy way to familiarize yourself with all the types and prices.

Sketch box

Aluminum tripod folding easel

Aluminum studio easel

Small French easel (expensive)

Setup

You need a strong directed light to shine on your indoor still lifes. The drawing on this page shows the kind I use, but you can get an inexpensive clamp-on light at the hardware store and put in an ordinary 200-watt bulb.

Turpentine

Turpentine (or a substitute) is necessary for cleaning your brushes while you are painting as well as afterward. Fill a pint jar about two-thirds full of the turpentine so you can really swirl the brush around to get the pigment out. Cleaning your brushes is very important. You don't need to clean them after every stroke, but it is necessary whenever you make a major color or value change. First, wipe your brush with a paper towel to remove the excess pigment. Then swirl the brush in the turpentine. Wipe the brush with a paper towel again. Swirl the brush vigorously in the turpentine again, and wipe the turpentine off the brush with a paper towel.

You will also use turpentine for thin washes of paint to stain your canvas. Staining takes the glare from the canvas. It neutralizes the color of the canvas so you can better see the color you're applying. Use just a little black and Phthalo Blue with the turpentine to make the stain, and wash it over your canvas. This mixture should be runny, about the same consistency as the turpentine, and of a middle to light value. I recommend staining the canvas, especially if you are painting outdoors.

I would stay away from paint thinner, even so-called odorless thinner. It still emits dangerously unhealthy fumes, even though you can't smell them. One product I have found essential since I am sensitive to paint thinners (which are petroleum products and therefore toxic) and turpentine is Livos thinner. It contains extract from citrus peels and other substances that I can tolerate without problems. It is expensive, but that can be remedied by allowing the pigment to settle overnight, or, at most, a couple of days, and then reusing it over and over again. It is available through Natural Choice. Be sure to order the Livos thinner, not Livos citrus thinner. The citrus thinner is too strong. Since I have been painting for quite a while, I am in the habit of referring to any thinner as "turps" and will do so throughout the book.

Outdoor Setup

My priorities are a bit different for painting outdoors—a thermos of coffee, snacks, folding chair (for breaks only!), folding easel, hat, sunscreen, an umbrella to keep glare off the painting and palette. If you must use dark glasses, be very careful in choosing the color. They should have as neutral a cast as possible because the color of the glasses will affect the colors you see as well as the colors you mix. Also, check what colors are reflected on your canvas from the surrounding buildings, cars and even the green grass.

Odds and Ends

I've already mentioned that you will need paper towels. You'll also need a small bottle of linseed oil to mix a bit with the paint in case it is too thick. You won't need much because most paints have too much oil in them already. Retouch varnish can be sprayed on your painting if the paint gets dry and the dark colors sink in or lose their intensity between painting sessions. Avoid breathing these vapors, and spray it outside. Also have at hand a two-inch cup for the linseed oil, a pint jar for turps or substitute, a TV tray and a sack for trash.

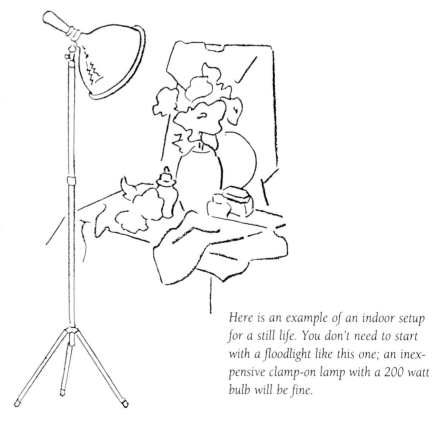

Here is an example of an indoor setup for a still life. You don't need to start with a floodlight like this one; an inexpensive clamp-on lamp with a 200 watt bulb will be fine.

Paints

You don't need the most expensive paints, but if you do use cheaper brands, it may be necessary to squeeze them out on absorbent paper to drain out some of the excess oil. It usually doesn't pay to get a so-called beginner's set because colors in these sets often look like the recommended pigments but will not always behave correctly in mixtures.

Studio-size tubes, 37 ml, or about one inch by four inches, are the most common and practical size for starting. You will use a lot of white, though, so you should buy the large size, 150 ml, or about one and a half inches by six inches. The colors I consider basic for all the paintings in this book follow.

Necessary:

▶ *Cadmium Yellow Light.* A slightly warm yellow; opaque. In some brands it is slightly cooler, or lemon colored. Get the warmer one.

▶ *Cadmium Red Light.* A warm red; opaque.

▶ *Alizarin Crimson.* A very cool red; transparent. This color has been used by artists for centuries because of its beautiful qualities, even though it is not considered totally lightfast.

▶ *French Ultramarine Blue.* A warm blue. The French Ultramarine Blue is slightly more transparent than Ultramarine Blue, but for most purposes, it makes little difference.

▶ *Phthalo Blue.* A very powerful, cool blue; transparent. Be careful with this one. You could probably paint a lot of paintings without this color, but when you need it, for a dark, dark for instance, it is essential.

▶ *Permanent Green Light.* This is a bright, clear green that I find essential when I paint. I've noticed lately that each manufacturer has changed the formula in a different way. Some now include Phthalo Green, which is too

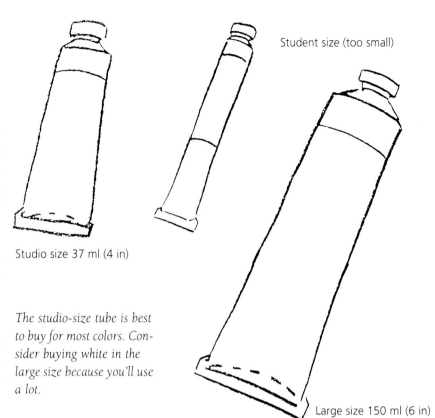

Studio size 37 ml (4 in)

Student size (too small)

The studio-size tube is best to buy for most colors. Consider buying white in the large size because you'll use a lot.

Large size 150 ml (6 in)

strong. You can make your own Permanent Green Light by using a little Phthalo Blue and Cadmium Yellow Light and a touch of Yellow Ochre. If you prefer to buy it, check the label, and avoid any that use Phthalo Green. I like Grumbacher Pre-tested Permanent Green Light.

▶ *Ivory Black.* The cleanest of the blacks. Essential and extremely useful in many mixtures.

▶ *Titanium White.* An opaque white. The basic white for most painting. There are other mixtures, such as soft whites or nonyellowing whites, that will also do quite well. Pick your favorite, but avoid Pure Zinc White because it does not cover as well and tends to crack when applied thickly.

▶ *Yellow Ochre.* A muted yellow. You can mix it from yellow and other colors, but it is inexpensive and more convenient to buy than to mix yourself.

▶ *Burnt Sienna.* A muted red-orange, also inexpensive and convenient to buy.

▶ *Cadmium Orange.* You can get this color easily by mixing Cadmium Red Light with Cadmium Yellow Light, but I find it so useful in so many mixtures that it isn't worth the trouble to make my own.

Very useful:

▶ *Cerulean Blue.* True Cerulean Blue is a wonderful light blue-green that is valuable for subtle tones such as those found in sky mixtures and cool flesh tones.

Occasionally:

▶ *Cadmium Yellow Lemon.* A brilliant, cool yellow that I find useful for bright whites in the sunlight in cool paintings.

▶ *Phthalo Red Rose.* An intense cool red that is not quite as cool as Alizarin Crimson. Useful when a painting contains many different reds.

Palette

It is important to have a large, white palette, at least 18″ × 24″, so you can lay out a fair amount of paint and have plenty of room to mix lots of paint. You can use a paper palette for ease of cleaning, but don't skimp on size! A sheet of white Formica is good or a sheet of glass with a piece of Masonite painted white and placed underneath is great.

Arrangement of Paints

Your palette is a valuable tool for your painting. It is much more than just a place to squeeze out your paints; you could think of it as an instrument, or a "keyboard," that you use to make beautiful harmonies with color.

It is important to arrange your paints on the palette in a way that makes it easy to reach the right colors for the mixtures you need as you paint. Once you make this decision, you should use it consistently, making only minor modifications if you find a new idea that works better for you. You need to be able to reach automatically for the color you need without searching all over the place for it. For the best color results, make decisions quickly and mix quickly before you forget what spot you were mixing for. Over the years, I have found that the arrangement shown here works best for me. Notice I have two large mounds of white, one for primarily warm mixtures and one for primarily cool ones.

Cadmium Yellow Lemon Titanium White (two) Cadmium Yellow Light Cadmium Orange Cadmium Red Light

Permanent Green Light

Phthalo Red Rose

Cerulean Blue

Alizarin Crimson

French Ultramarine Blue

Yellow Ochre

Phthalo Blue

Ivory Black

Burnt Sienna

Use a big palette, about 18″ × 24″. Also use big blobs of paint, not little dewdrops.

Palette in sunlight

Mixing colors on your palette. These are examples of how I mix color into color to achieve more harmonious paintings. They also show why you need a palette big enough to mix colors. Notice the remarkable difference in the light quality between sunlight and shade. There will be much more discussion of light quality in future chapters.

Palette in shade

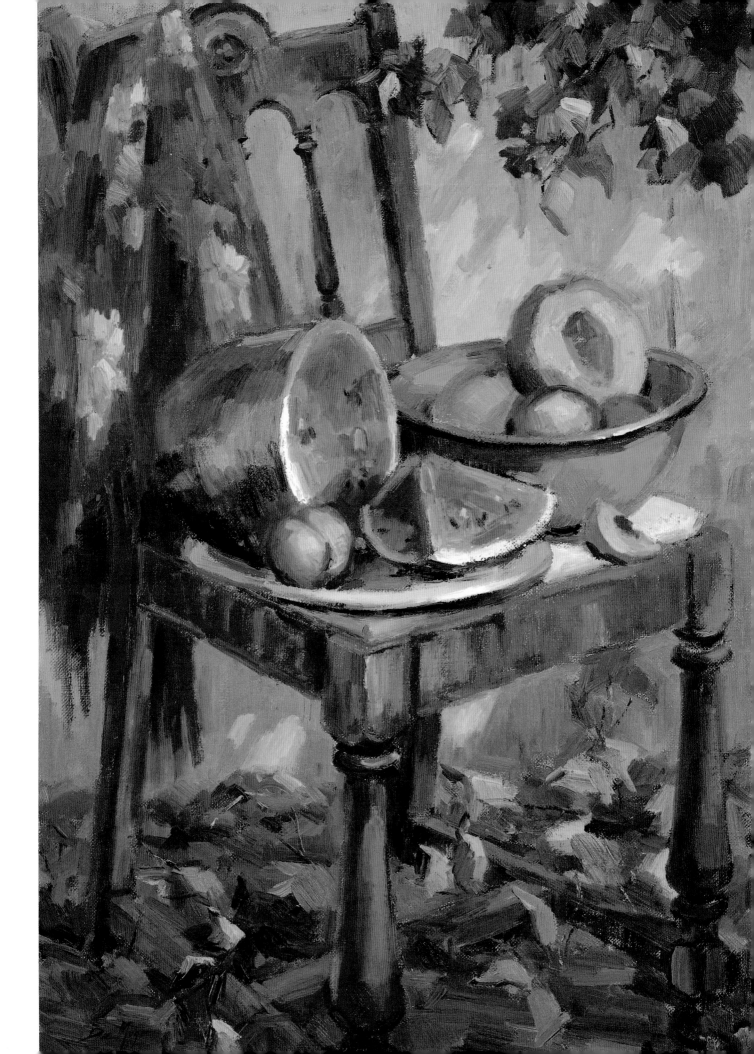

BASIC COLOR AND PAINTING PRINCIPLES— MADE EASY

The Best Way to Learn From This Book

Before we start with principles and demonstrations, I want to encourage you to use this book any way you want to. Look at the paintings, read a few tips, relax with it, or dig right in! However, nothing will happen until you start something. Don't be afraid to try. I get scared, too, but I've learned that the only way to get "unscared" is to do it.

The book is arranged in the most logical sequence to make it easy to progress. For instance, this chapter covers some basic but essential principles. But if you are attracted to one subject more than another, go for it, and skip what you don't like. You can always come back to it later (when you finally realize it was a good idea). I prefer to give as few rules as possible, except for the ones I feel are important.

Each lesson in this chapter and in the demonstrations in the following chapters is intended to present a *very important* underlying principle that will help you with future paintings, as well as the particular painting you are working on at the time. You will also notice that I bug you repeatedly about things that are *very* important. These are things that I've found both my students and I are resistant to doing but which cause no end of grief when they are ignored!

◄
RED CHAIR AND MELONS
36" × 24"

Get Familiar With Your Paints

The best way to get to know what your paints and brushes will do is to play around with them. I can't emphasize this enough. Get out some paper, mat board, museum board, chipboard, with or without gesso, or even the backs of tablets, and just start messing around, noticing what happens when you:

- ▶ mix each pigment you have with every other one
- ▶ add black to each color (tends to make it look warmer)
- ▶ add white to each color (tends to make it look cooler)
- ▶ do little rough sketches using two colors plus white
- ▶ do little rough sketches using three colors plus white

Fun Little Exercises

Go ahead and play with the color combinations I show here.

Black, Yellow Ochre, Burnt Sienna and white

Ultramarine Blue, Alizarin Crimson, Cadmium Yellow Light and white

Cerulean Blue, Alizarin Crimson, Cadmium Yellow Light and white

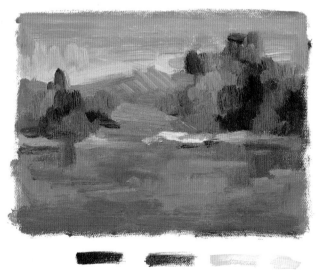

Ultramarine Blue, Alizarin Crimson, Cadmium Yellow Light and white

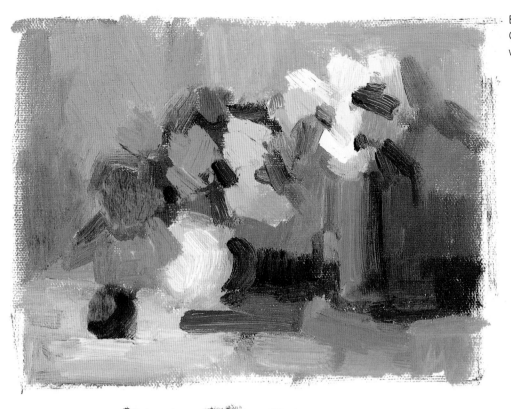

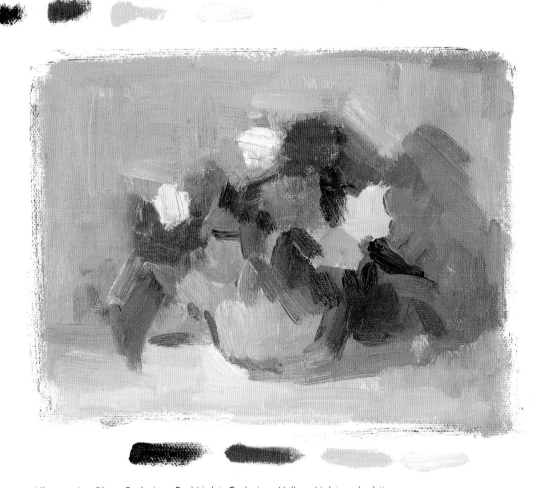

Ultramarine Blue, Cadmium Red Light, Cadmium Yellow Light and white

Learn to See Color

Learning to see color is one of the most exciting aspects of painting. One of the first steps in this process of seeing color is to put aside all your prejudices about what color an object actually is.

Get into the habit of realizing that all color is reflected light and that everything to some degree is a reflective surface, even fairly "dull" objects. All surfaces are influenced by the light that is shining on them and by the light that is bouncing off other objects nearby. This is a harmonizing effect of light. Learn to be aware of and sensitive to this effect of light, and it will help you create harmony in your paintings.

When a light shines on an object, it has a definite effect on the appearance of that object. The area that is in the light will take on some of the color of the light. The area that is in shadow will take on some of the complementary color which is the color across the color wheel from that of the light. For example, when using an incandescent bulb, which is yellowish, a red apple will appear to be slightly orange in the light and slightly red-violet in the shadow, and a green leaf will appear yellow-green in the light and blue-green in the shadow.

It is also helpful to discard descriptive names for colors, such as "avocado green" or "sky blue" or "coral." This kind of thinking limits your perception of the infinite variety that exists in the spectrum of color, therefore limiting the variety of colors you will be sensitive to.

One exercise I like to give students when I teach is to ask them to mix up forty different variations of greens as homework. Then when they bring them to class, I ask them to name them. You should hear the groans! Of course, I am just kidding about the names, but that is my point: The names are not important; the colors are.

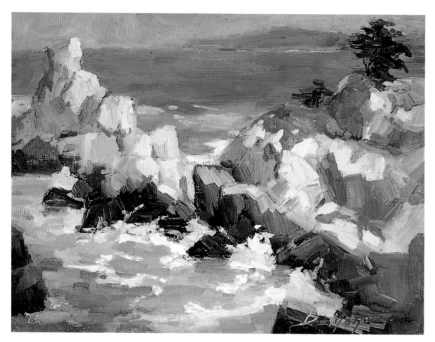

Landscape in warm light

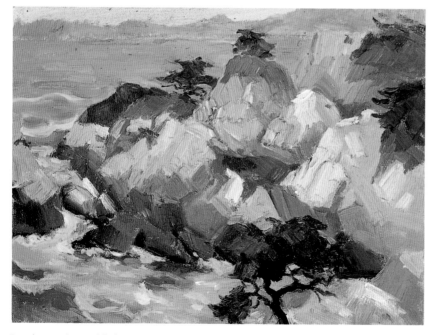

Landscape in cool light

Characteristics of Color

There seem to be an uncountable number of colors, and at first, it may seem a bit scary to try to understand color theory. I will show you a way to think about color that will make it much easier to understand.

Every color can be described by three different characteristics: value, hue and intensity. Once you understand these, you will be well on your way to understanding color.

Value

First, let's consider value, which is simply the lightness or darkness of a color. It's what you see in black-and-white photographs. Value is the component of color that we respond to first, even though it may seem it is the "color," or hue, of an object that grabs our attention.

You probably have heard or will hear of "the key of a painting." The key of a painting is determined by the dominant value in the painting: Low key is dark; middle key or high key is light. Different keys can express different moods; for instance, a low-key painting tends to be somber, and a high-key painting tends to be happy.

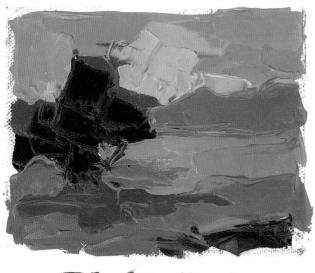

Low key

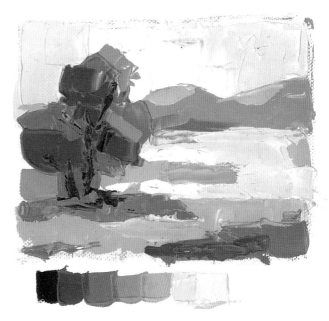

Middle key

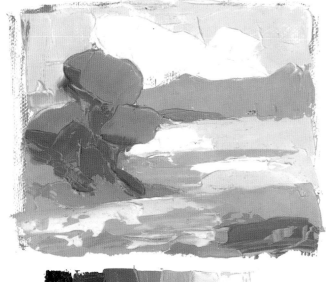

High key

These paintings show the influence of light on color. Notice the colors I chose suggest the warm light and cool light.

Value scale

Hue

Hue is what most people think of when we ask, "What color is it?" A standard color wheel shows hue.

Notice that the hues of some colors are darker and some are lighter. Yellow, for example, is the same value as a very light gray, almost white, and purple is the same value as a very dark gray.

Warm Versus Cool Color

Artists often talk about color in terms of "temperature," or warm and cool colors. Temperature is a fine tuning for hue and is important for the expression of light and mood in a painting.

In general, red, yellow and orange are considered warm colors. Blue, green and violet are classified as cool colors. However, it is the relationship *between* colors that is important to understand in painting. For example, a red that has more yellow in it, such as Cadmium Red Light, appears warmer than a red that contains more blue, such as Alizarin Crimson. However, Alizarin Crimson is warmer than a blue-violet. And a blue that has more red in it, such as Ultramarine Blue, is warmer than Phthalo Blue, which is considered to be the coldest color on the color wheel. Yellow-green is warmer than blue-green.

The important thing to remember is that the terms "warmer than" and "cooler than" imply a relationship between two colors.

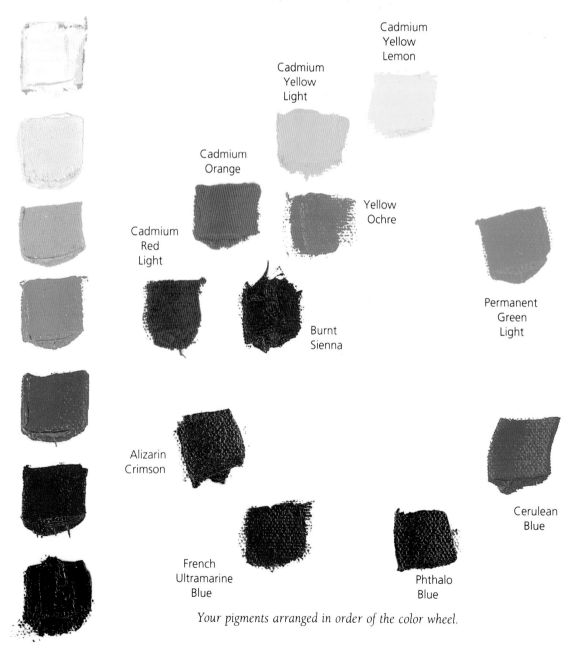

Cadmium Yellow Lemon

Cadmium Yellow Light

Cadmium Orange

Yellow Ochre

Cadmium Red Light

Permanent Green Light

Burnt Sienna

Alizarin Crimson

Cerulean Blue

French Ultramarine Blue

Phthalo Blue

Your pigments arranged in order of the color wheel.

Intensity

The third characteristic of color is the intensity, or how rich or muted, bright or dull a color is. Any time you add a color to the original color, it will lose some intensity. If you add white to a pure hue, you make a tint.

If you add black to a pure hue, you make a shade. When you add any combination of colors or black and white to the original color, you create a tone.

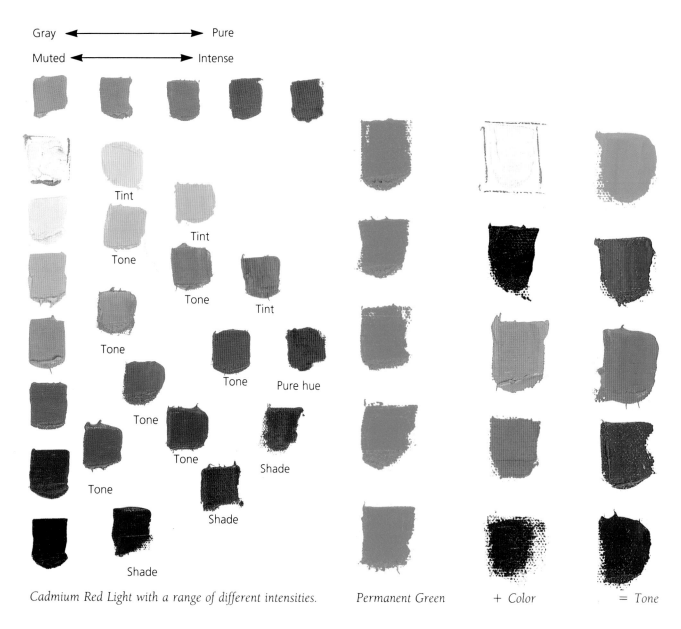

Gray ←————→ Pure

Muted ←————→ Intense

Tint

Tint

Tone

Tone

Tint

Tone

Tone

Tone

Pure hue

Tone

Tone

Shade

Tone

Shade

Shade

Cadmium Red Light with a range of different intensities. *Permanent Green* *+ Color* *= Tone*

Think of a Globe

Other pigments and their modifications are shown on these pages. When you look at them, think of a vertical slice of a globe in which

- ▶ the black spot on the bottom left is the South Pole
- ▶ the white spot on the top left is the North Pole
- ▶ the intermediate shades in between make up the earth's axis

▶ the pure hues are on the equator with the axis tilted so that, for example, yellow, which is the same value as light gray, falls in the Northern Hemisphere and purple, which is the same value as a very dark gray, falls in the Southern Hemisphere

▶ tints (when you add white) are on the surface between the equator and the North Pole

▶ shades (when you add black) are on the surface between the equator and the South Pole

▶ tones (when you add any combination of colors or black and white) are located in an orderly way in the interior of the globe

Use these charts for an idea of the approximate location of a color on the color globe.

Cadmium Yellow Light

Alizarin Crimson

Cadmium Orange

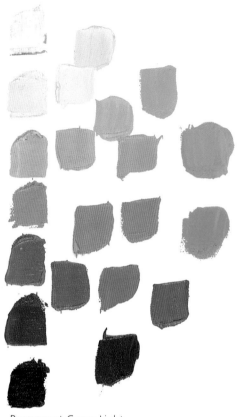

Permanent Green Light

Phthalo Blue

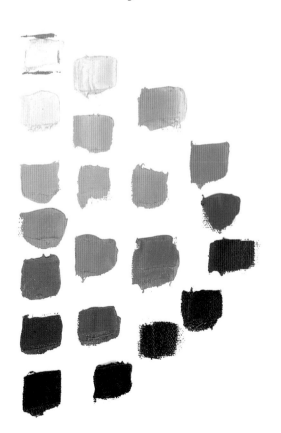

Ultramarine Blue

Put It All Together and Paint!

When I paint, I usually start with a dark area and compare it to other dark areas, to establish the key of the painting. Next, I choose a fairly intense color and compare it to other color spots in the same family. Perhaps I choose a bright red flower and compare it to other reds in the setup. Some may be lighter, some darker, some more intense, some paler, some cooler, and I paint all of those spots.

Next, I choose some other color family, maybe blues or greens, and do the same thing. When you glance around the setup, it is important not to stare too long at a single spot; it is better to squint or glance quickly, especially when you are trying to find the colors in shadows or spots that consist of very subtle harmonies.

You will find that the same object in different paintings will appear to be different colors and need to be painted with different combinations of pigments. This is because of its relationship to other objects in each painting.

The secret words are *squint* and *compare*.

Remembering all of this when you first start to paint can be a bit overwhelming, so don't worry about it too much. Just try to observe the differences in color spots as you paint, and you will gradually see and understand more and more.

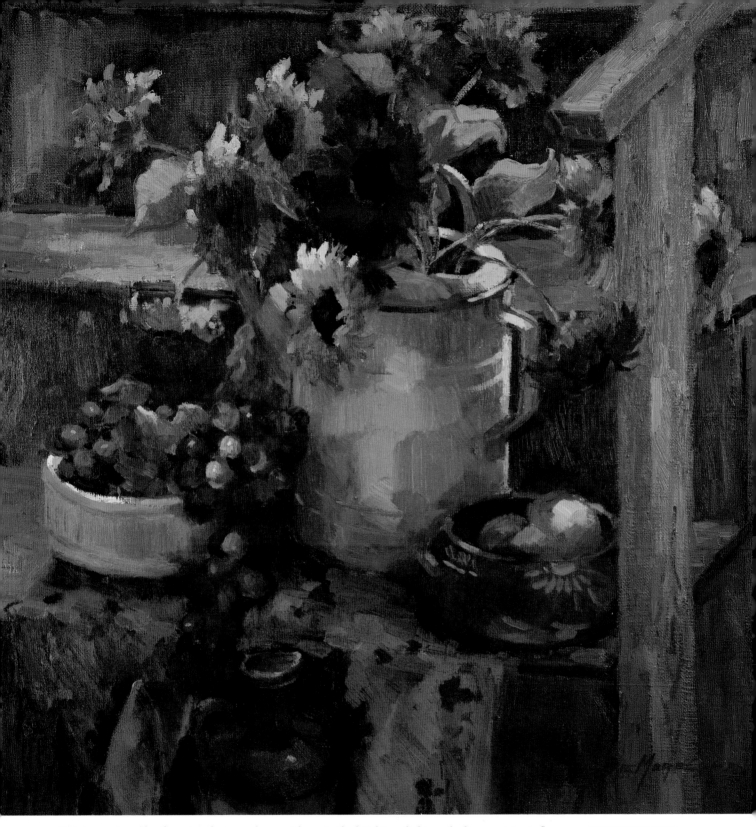

This is an example of a setup that was done outdoors in the bright sunlight, so the harmonizing influence of the light is warm, with resulting cool shadows. The largest area of the painting is in shadow and consists of cool objects—the watering can, the blue shawl, green leaves and the old wooden steps—so the painting is dominantly cool. Since it is backlit, there are only small areas of bright, warm colors— reds, yellows and oranges—on the flowers and pottery. There are many areas of transition colors, or tones that harmonize the very intense warm and cool colors and help unify the painting. This is a middle-key painting using the full range of values from dark to light, with most of the values lying in the midrange.

WATERING CAN
30″ × 30″

A Bit About Drawing

When you first start painting, you may not like to think too much about the importance of drawing. I didn't either. However, unless you are into nonobjective art, it is really important to make things look as good as you can and put them in the right place. So in the next few pages are examples of a few things to watch out for in your paintings. You don't have to be a master draftsperson, but think about these ideas, and your paintings will have a more professional look, even if some things are a bit off.

DRAWINGS ON NEWSPRINT

A fun way to loosen up is by drawing stuff on newsprint using black with just enough turps to produce a sketchy line. This exercise will make it easier to get started on canvas.

30

Four Basic Forms

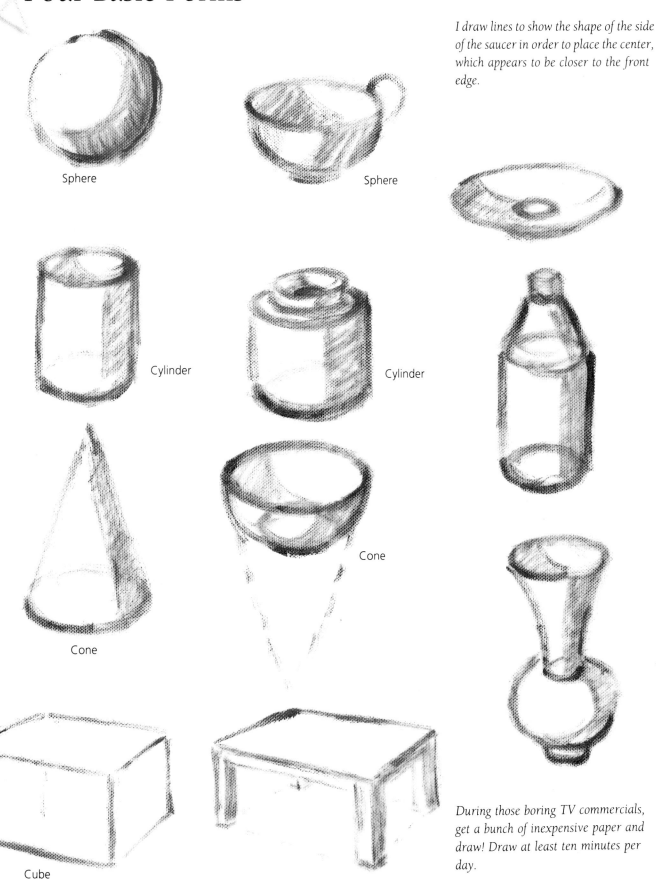

I draw lines to show the shape of the side of the saucer in order to place the center, which appears to be closer to the front edge.

Sphere

Sphere

Cylinder

Cylinder

Cone

Cone

Cone

Cube

During those boring TV commercials, get a bunch of inexpensive paper and draw! Draw at least ten minutes per day.

Two Easy Perspective Rules

Rule 1: Ellipses. The tops and bottoms of jars, plates and bottles that are closer to eye level are narrower. Rule 2: For any two parallel lines, the one closest to you is always longer.

Exercise: Get a coffee can and look at it from different levels. Draw the top of the can as pictured here.

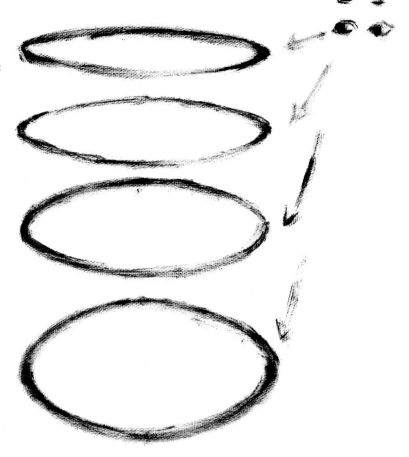

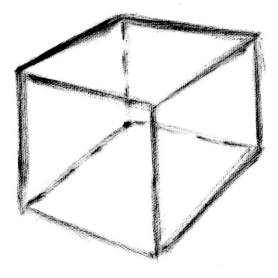

Look at pairs of parallel lines in this sketch. The line closest to you is always longer.

Placing Objects

When placing objects, draw through as if everything were transparent. This avoids the impossible situation of having two objects occupying the same space at the same time. Try some of these experiments yourself.

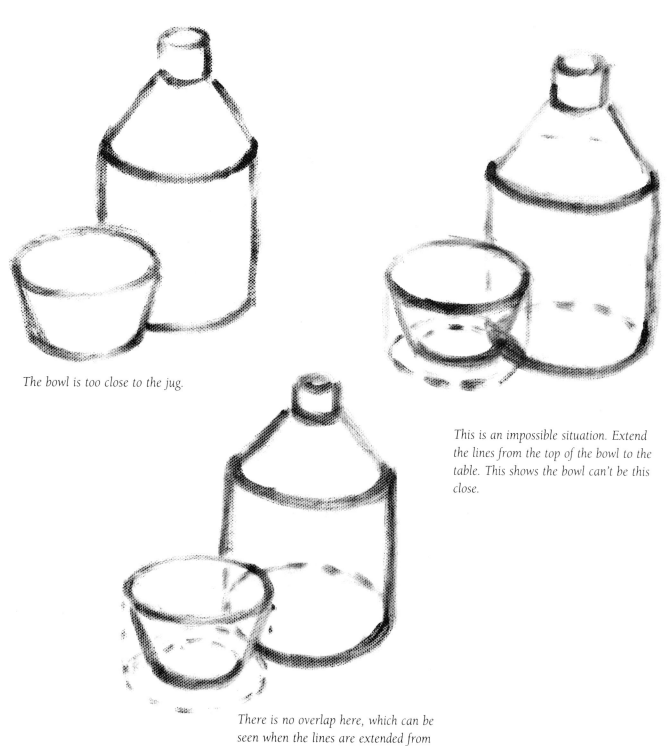

The bowl is too close to the jug.

This is an impossible situation. Extend the lines from the top of the bowl to the table. This shows the bowl can't be this close.

There is no overlap here, which can be seen when the lines are extended from the top of the bowl to the table.

A Few Composition Dos and Don'ts

Don't divide the painting in half either vertically or horizontally. Make uneven spacing between objects. Use odd, not even, numbers of similar objects, and vary sizes. Don't put tall, thin objects on the edge.

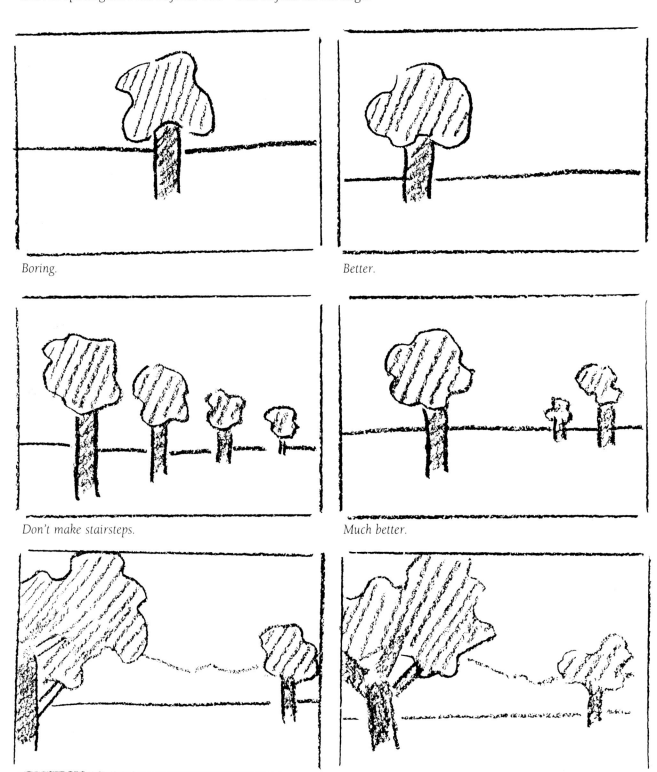

Boring.

Better.

Don't make stairsteps.

Much better.

Don't let objects kiss the edge.

Shapes can be cropped or leave space.

. . . And a Few More

Avoid lines going out of the corners.
Don't place objects directly over each
other; arrange them randomly.

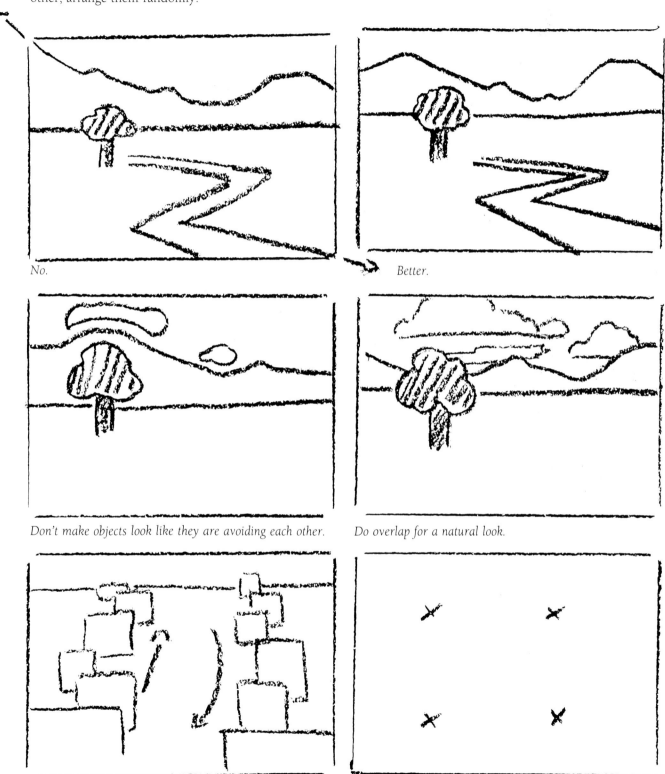

No.

Better.

Don't make objects look like they are avoiding each other.

Do overlap for a natural look.

Overlap to create space and distance and to guide the viewer in and out of the painting.

This shows good places for focal areas.

A Few Words About Technique and Style

You might worry about technique and what the "right" way to do something is. Or you might worry about what "style" you should paint in. The truth is that painting should be natural and not forced. I do have a couple of suggestions, like how to hold a brush and how to scrape correctly, but other than that, you should experiment to find ways that work best for you. Work with paints and brushes in ways that feel comfortable to you, and your style will develop naturally and be unique to you.

You can learn a great deal from studying the work of other artists, but don't try to imitate their styles. Instead, take what you learn and make it your own.

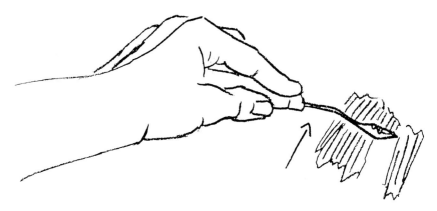

How to Scrape. Hold the knife so the blade will scoop up the paint as if it were a spoon, and then scrape once upward.

How to Hold the Brush

It is best to hold the brush toward the end when you are actually applying the paint. This enables you to stand away from the canvas and to better see what you are doing. In fact, that is why the handles are long.

When you are doing the drawing, you might hold the brush up closer to the ferrule, which is the metal part that holds the bristles, for more control. Do not hold it like a pencil, though because this will constrict the flow of your drawing. You should draw with your whole body, not just with your finger and wrist muscles. One way to assure this is to place your palette in front of you between you and the easel.

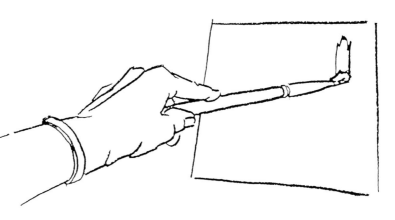

Holding the brush. Hold the brush toward the end when you are applying paint.

How to Scrape

Instruction on how to scrape may seem a bit picky, but it is important because you will scrape off a lot of unwanted spots. I certainly do. The best way is to hold the knife so the blade will scoop up the paint as if it were a spoon, and then scrape once upward. Wipe the knife clean before you make another stroke. Be careful not to use it like a butter spreader, which may seem natural for a beginner. This will grind the pigment into the canvas rather than lifting it off.

Brushstrokes

Experiment with different brushes
and see how many different kinds of
marks you can make.

*Brushstrokes. Try holding the brush in
different ways: at the end or close to the
ferrule. Make the stroke in different
ways: on the side, with the point, holding
it flat against the canvas, any way you
can think of.*

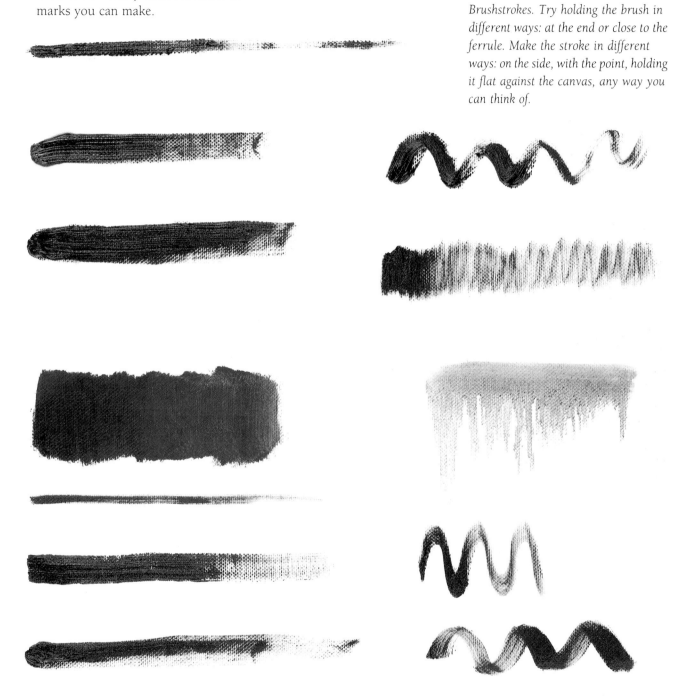

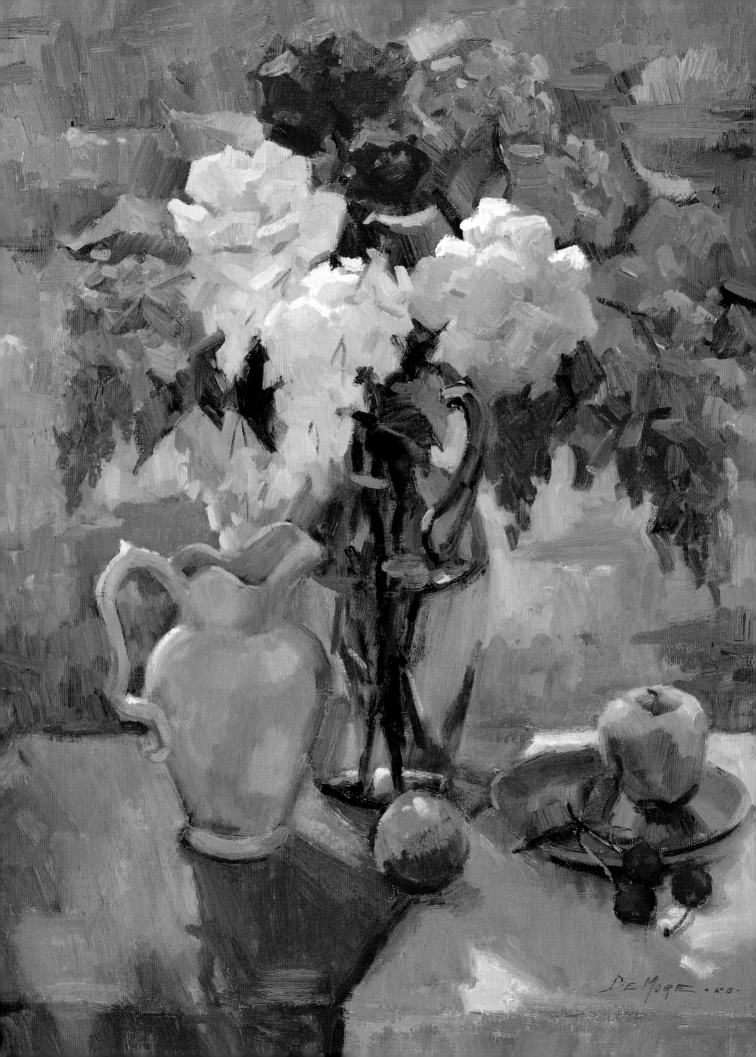

Chapter Three

PAINT STILL LIFES

Read This First

Before we even begin the step-by-step demonstrations in this chapter, please take a look at the simple but important reminders I've listed here. Oil painting can be lots of fun and can be very rewarding, especially if you develop good habits. Most of the frustrations students encounter can be traced to poor habits, so refer to this page often. In fact, you might want to make a photocopy and hang it where you can see it while you paint.

1. Always paint from life. This is most important. Don't copy photographs. The color, camera, film are always wrong.

2. Sqeeze out lots of paint. There is no way to good color if you are stingy with paint. Oil paint is meant to be laid on the painting surface, not spread as thinly as possible or diluted with lots of medium. This requires a large palette, at least 18″ × 24″. When you mix colors, you need lots of room, and the palette provides a visual experiment before you place it on the canvas.

3. Do lots of looking. Stand back often. If you stare too long at small areas, your eyes get tired and you can't see your mistakes.

4. Make lots of mistakes. What? Yes! The only way you can discover what works is to try it. Paint faster than you are comfortable with and do a lot of scraping. Use your palette knife for scraping, not mixing paint. I call this "experimenting."

◄
SUNDRENCHED LILACS
30″ × 24″

Prepare to Paint

Before you begin actually painting, take time for some all-important preliminaries. Decide what you want to include (composition), how you will arrange objects (design) and what you want to focus on (center of interest) in your painting. Drawing is included in this preparation.

It is *so* much easier to prepare and make changes now than after a lot of work has already gone into the painting. I learned this the hard way, too.

Three Stages of the Painting Process

The best way to approach a painting is to think of the process as being divided into three stages: (1) the beginning, where you establish simple, flat shapes of color; (2) the middle, where you establish form, or the feeling of volume in objects; and (3) the final stage, or finish, where you put in the detail. In each of the demonstrations in this book, you'll find a pattern similar to these stages.

The First Stage

To begin each painting, you will block in large, simple, flat shapes of harmonizing color, usually starting with the darks. Next, look for the brightest colors, because they are easier to see and mix. Cover the largest areas with the bright colors. Finally, look for the more subtle colors. You must constantly resist the temptation to finish any one area in this stage. Recheck your drawing and the placement of objects, because it is easier to make changes now than later.

The Middle Stage

When you feel confident you have made as many adjustments in color relationships as necessary, begin to model or give shape to the forms of objects and refine their silhouettes. Continue to refine color relationships and soften some edges. This middle stage will require the most time and attention. You still *must* resist the temptation to put in the details.

The Final Stage

When you feel there are no more major changes, you can finally allow yourself to put in details, such as leaves, stems and highlights.

There are good reasons to follow these stages. First, it is difficult to see exactly how a color will look until the whole canvas is covered because any color looks different next to a white background than it looks next to another color in the painting. Second, it is difficult for a beginner, or any artist, to make changes once too much work has gone into any one area. Third, since different areas of a painting require different degrees of finish—for example, the center of interest, or focal area, should have a little more finish, or detail, than other areas in the painting—all parts of the painting should progress simultaneously because the painting might be done before you know it!

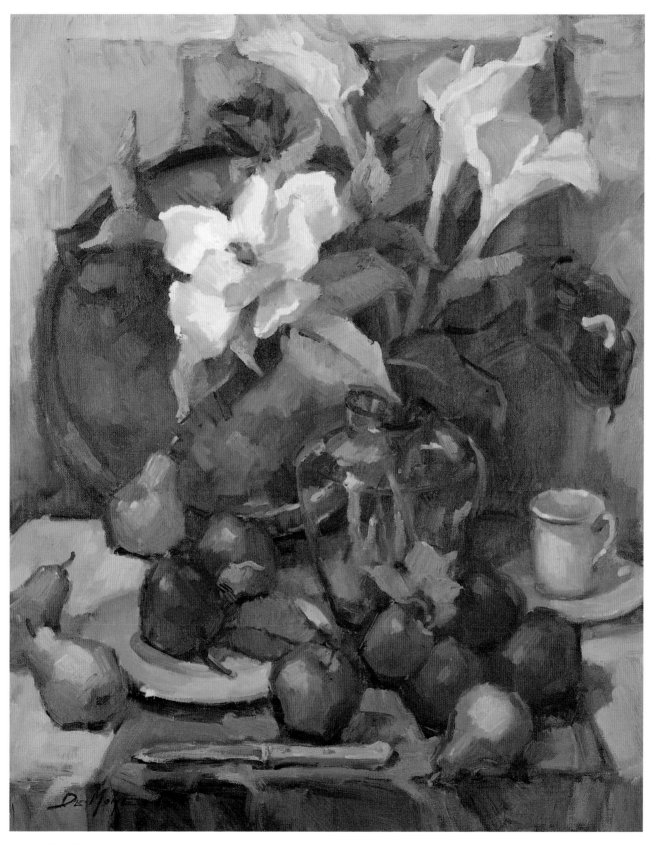

PERSIMMONS AND MAGNOLIA
30″ × 24″

Painting Primer: Use Edges

A variety of edges in a painting is important for a number of reasons:

1. Edges explain the hardness or softness of objects.
2. Edges explain the roundness or sharpness of objects.
3. Edges allow the eye to move around the painting.

It is up to you as the artist to decide where to soften some edges or where to lose some.

▶ Consider losing an edge where the values are the same, such as light next to light, dark next to dark or middle next to middle.
▶ Consider softening an edge where values are similar and where you want to minimize attention.
▶ Make edges more crisp where you want the viewer's eye to focus
▶ Experiment with your brush to see how you might soften and lose edges.

Hard, soft and lost edges. Experiment using black and white to find your technique for softening or losing edges. It's easier to practice in black and white.

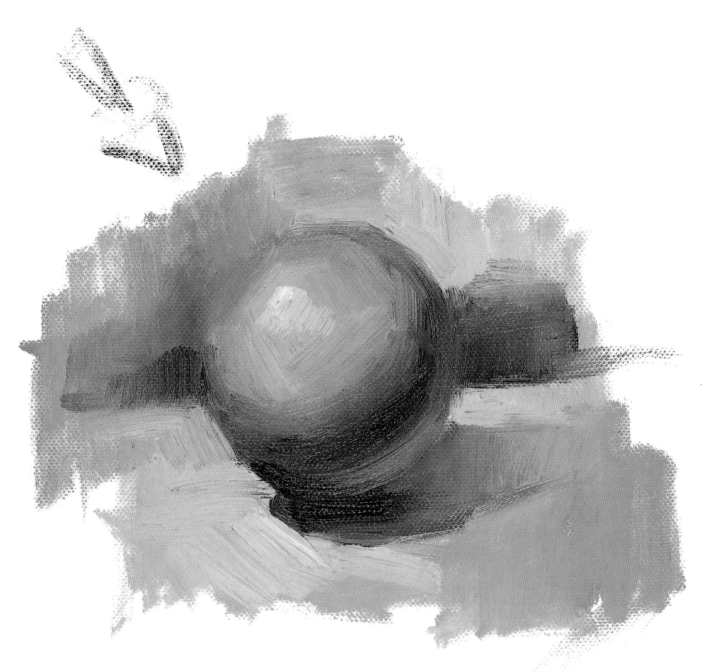

Example of different edges. Notice in the upper left of the ball shape how the edge is lost where the middle values meet, the soft edge showing the turning shadow on the inside of the ball, the hard edge at the right upper portion where dark meets light. Study this example for other gradations of edges.

Paint in Black and White to Understand Values

It may sound boring to do a black-and-white painting when most of us are initially attracted to a painting by color. Believe it or not though, the viewer first responds to value, then to the other components of color. The most important thing to remember is that if the value is wrong, the color is wrong! By eliminating the color, it is easier to focus on the values, drawing and manipulating the paint.

When you set up any still life, plan as carefully as if it will be a masterpiece. This helps you keep your enthusiasm high. It is *not* a waste of time and energy to do this planning for what may seem to be an inconsequential piece. The planning and thinking and practicing will drive the principles into your subconscious so they will, with little thought, appear later when you need them.

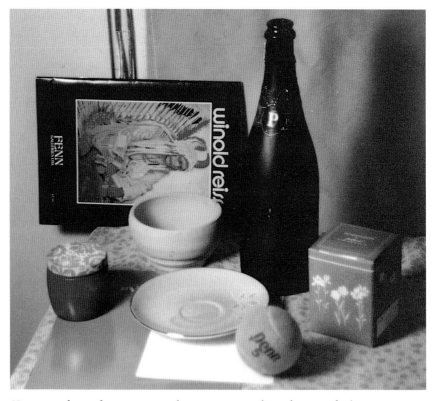

Here is a photo of my setup. Look at your setup through a viewfinder or your fingers.

Setup

Look for a variety of objects with values ranging from black to white. This helps train your eye to separate this all-important component, value, from the local color, which is what we think of when we see a red apple or a white bowl or blue water. Choose a variety of sizes and shapes, and arrange the objects into a pleasing composition. Check to see how this will look by standing behind the easel and looking through a viewfinder or your fingers. You could also make a little pencil sketch to double-check how it will look on a flat surface. With practice, it may not be necessary to do the sketch.

Lighting

Shine a 200 watt bulb on the setup, placing it either to the right or to the left and slightly higher than the subject at about a 45° angle. Adjust it to provide the best distribution of light and shadow. It is important to control the lighting in this way because then it is easier to observe the differences between the light and shadow. This is especially helpful when you first learn to paint.

Placement

Always stand so that you can step back often to better see how the painting looks. A passage can look wonderful up close, only to discover it's in the wrong place or the wrong color when you stand back. Place the palette between yourself and the easel on a TV tray so you won't stand too close. Then the colors you see on the palette are the same distance from your eye as those on the painting.

Adjust the painting height to approximately eye level to avoid distortion.

It's easy to make a viewfinder with two pieces of cardboard cut into L shapes. Hold the L shapes so that the opening between them is proportional to the canvas.

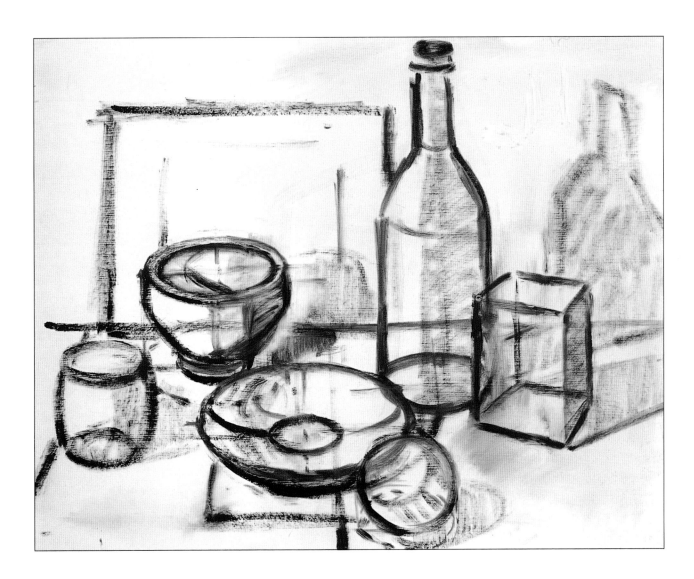

Step One

Draw in Shapes

Draw directly on the canvas using a no. 6 filbert with black and a slight bit of turpentine. It should be fairly dry, not runny. If the lines are rather thick and are allowed to show through a bit during the painting process, they give a bit of calligraphy to add to the structure of the painting. You can erase any mistakes as you go by using a paper towel moistened with turps. Never use pencil to do the drawing; it will eventually bleed through. Charcoal is too messy and will dirty the color.

A helpful trick when drawing is to make small dots indicating the high- est and widest points and the major divisions of the composition. You can then see if everything fits on the canvas correctly before you get too in- volved in drawing smaller objects. Also, it can be useful to draw the cen- terline of bottles and ovals to make it easier to make both sides match. For bottles and jars, draw a vertical line, then draw one side of the jar. Keeping your eye on the first side, draw the other side.

Viewers respond to variety. It is important to make unequal divisions and unequal-sized shapes, as well as interesting and different shapes. Try to have large, simple shapes to con- trast with the smaller, more complex shapes.

Draw everything as if it were trans- parent (see page 33) so you don't end up with the situation of two objects occupying the same place on the table.

Stand back often and use a mirror to check your drawing by turning your back and looking in the mirror over your shoulder. I learned the hard way that it is easier to make changes now. Listen to that little voice that says, "It's wrong!" Correct it now. Whatever is wrong won't go away be- cause there's more paint on it.

Step Two
Start to Paint

Start this step with a no. 10 filbert. Use the largest brush you can to avoid getting too fussy too soon. Begin with an almost black area and just lay in flat shapes, no modeling. Gradually work your way to the lighter areas. Sometimes, I paint in the lightest light fairly early in order to compare the relative lightness or darkness of the spots.

Notice that I have reserved the pure white for the highlights and that the value for the white paper is slightly lower. This is an important principle. The range of values of any subject is much greater than the range of values that is possible to portray in any painting. Artists must simplify and be careful to translate the values they see. That means the darkest object in the subject should be the darkest spot on the painting and so on. Keep your eye moving constantly around the still life as well as your painting, comparing the relative values of spots.

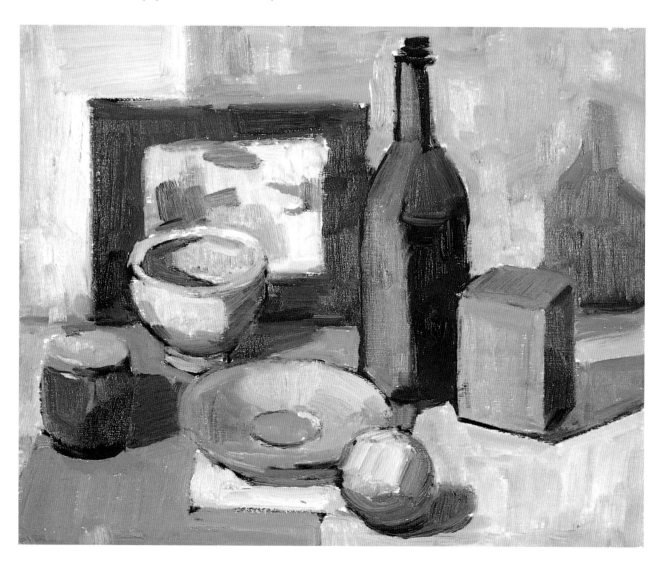

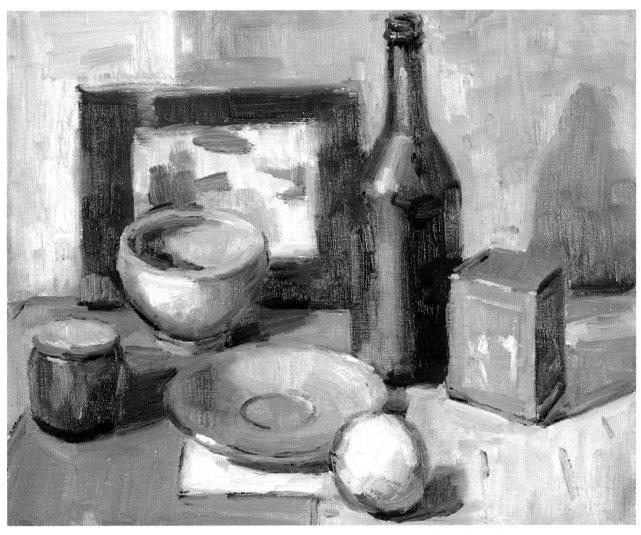

STUFF 'N' JUNK
16″ × 20″

Step Three
Model and Finish

During this step, you will make the objects look three-dimensional on a two-dimensional surface. To give this three-dimensional illusion, areas are blended where light meets dark. In a black-and-white study like this, blending will change the value in that area to an intermediate value and will help to make the object look round.

This step includes the addition of highlights and a few finishing touches since there is very little detail in this painting. Notice how white the highlights are compared to an object that is supposed to be white.

Painting Primer: Painting Flowers

I feel that painting florals is the best way to learn to see and compare colors. Flowers are fun because there's an infinite variety of shapes as well as colors.

Before each demonstration, I will show you how to look for the simplified shape of the flowers used so that the result will be a beautiful impression of the kind of flower you are painting. Of course, for the demonstration paintings, we will be using artificial flowers so they won't change or wilt before you get done with the painting. There are beautiful silk flowers available, and even plastic ones will do if they are the right color and shape.

Step 1. Draw a silhouette.

Step 2. Block in shadow and light spots.

Peony

Flowers can be simplified into one of the four basic forms. Think of the peony, which you will paint in the next demonstration, as being ball shaped. This makes it easier to represent it convincingly in a painting. If you tried to paint every tiny spot of light and dark you see, you would have a confused and unconvincing painting. It is important to understand that we are creating an illusion of a three-dimensional form on a two-dimensional surface. A painting is an abstraction and not a photograph.

Step 3. Give the peony form by softening the area where light meets shadow.

Step 4. Paint in petals, stems and accents.

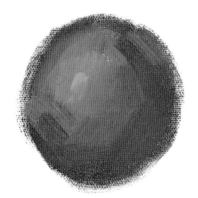

Think of the peony as being ball shaped.

Side View of a Peony

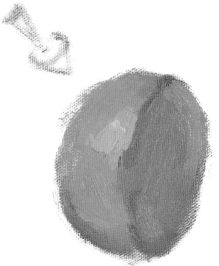

Step 1. Draw in the silhouette.

Step 2. Block in shadow and light spots.

The side view of a peony looks like a hemisphere. In this case, the cut is facing away from the light.

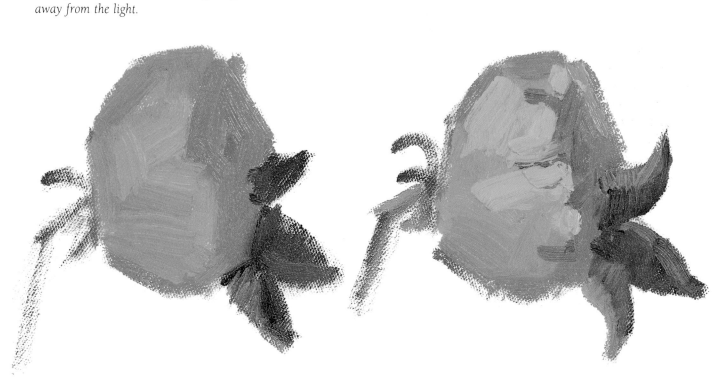

Step 3. Give the peony form by painting in a halftone and blending. A halftone is a color that appears where the light meets shadow, and it is richer than a color that would be obtained by simply blending. Just do the best you can with this, and if it looks OK by just blending, don't worry about it. These subtleties will come as you continue to paint.

Step 4. Add details. Suggest a few petals, calix and stem.

Your First Floral Painting

Setup

For this setup, I chose fairly simple flowers and objects to make the drawing easy. I decided on a harmony of reds and greens. These are colors that are opposite on the color wheel and are considered a complementary harmony. Notice that there are a number of different reds, ranging from almost violet to a red with a bit of orange in it. Also, there are very cool bluish greens to warm yellow-green.

When I prepare to set up a still life, I gather up more objects than I think I will need, and as I arrange them, I eliminate the ones that don't seem to work. Sometimes it is hard to eliminate a favorite object. Often, I have to leave out the very piece that inspired the painting in the first place!

Lighting

Shine a 200 watt light on the arrangement. This not only describes the form of objects but provides a harmonizing factor as well. In this case, the light is a warm yellow and will influence all of the colors in the light to become a bit warmer. At the same time, all of the shadows will move toward the cool violet side.

Background

It is important to remember that the background is just as important as the flowers. Don't try to make up a background in your imagination. It will show in your painting because everything in an arrangement has an influ-

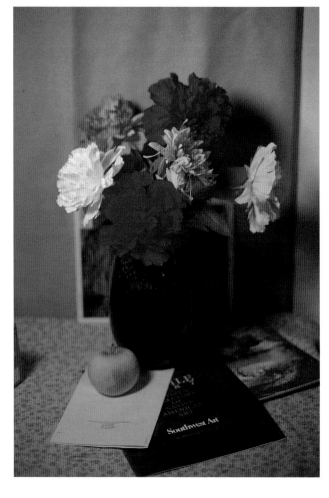

This setup photo looks much different than the painting will because the film is so sensitive to the incandescent light necessary to show the dramatic shadows. Remember that a painting is a result of translating color relationships onto canvas and not a copy of the subject.

ence on everything else. For example, a particular red flower will appear to be more orange, or warmer, next to a violet or blue, and it will appear more violet, or cooler, next to a yellow or orange.

Don't worry, it may be a bit difficult to see these differences at first, but as you continue to paint, you will become more sensitive to nuances of color. You can learn to find these subtle differences by glancing around the setup and asking yourself which red, for example, is the coolest, or has the

most purple in it, and then which is the next warmest and so on up to the warmest, or red-orange. Continue this process as you paint, comparing similar values, similar hues and so on.

As you begin painting, don't be discouraged if there seems to be a lot to learn all at once. Just do what you can and have fun. Gradually, things will fall into place.

Step One
Draw in Shapes

Begin with the preliminaries. Lay in the big shapes first: the back of the tabletop, the overall shape of the bouquet. Check to see where these should be placed by using a viewfinder before making a mark on the canvas.

Notice that I avoided placing the vase directly in the center of the canvas, even though the appearance of the arrangement is fairly centered and balanced.

When you draw the flowers and fruit, use straight lines whenever possible so it will be easier to get things placed correctly and, more importantly, to avoid everything looking like lollipops. This is the time to think about shapes and placement. I also suggest the shadows and dark areas in order to check the balance for design.

When you feel you have developed the drawing as far as you can, take a break, and come back to it later and check it with a mirror over your shoulder. This might save a lot of grief later.

It is also the time to listen to your intuition, that tiny little voice that says, "Something is wrong!" It is always easier to change now than later.

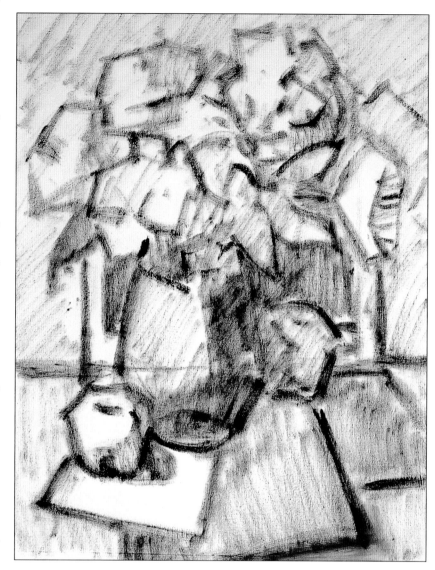

Step Two

Begin Laying in Color

Begin to lay in the darks. Scrub them in very thinly by using a thin amount of paint without much oil. Try to keep them transparent by avoiding white as long as you can. Sometimes, I thin the paint with just a touch of turps but no oil because you shouldn't use much oil in the early layers of a painting.

Compare the colors of the shapes to each other by constantly moving your eye around the setup as well as the painting. Keep the shapes as flat and simple as possible. You can divide the objects into light and shadow shapes, but avoid doing any modeling of form or details. This step and step three are in the first stage of the painting process where simple, flat shapes of color are established.

After painting the dark areas, choose the brightest colors, because they are easier to mix than the more subtle ones. Relate reds to reds, greens to greens and so on. I'll give you the approximate color mixtures to start you in the right direction, but remember, there are many ways to achieve a given color. Also, when involved in a painting, I sometimes mix the colors for different spots by adding new color to the mixture I already have on my palette, so it is impossible to give exact color combinations. You may have to use other mixtures on your painting to get the spot exactly right because everyone sees color differently and every painting is a slightly different harmony.

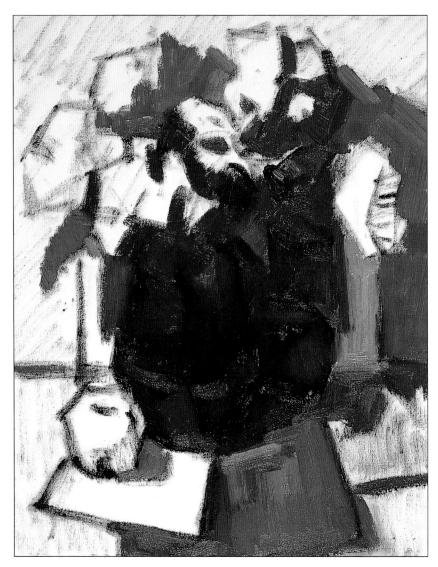

Begin laying in color, starting with darks. Try mixing black and yellow for the warmest green of the foliage on the left. The foliage on the right is cooler, so you can try green, blue and white. Try Ultramarine Blue, Alizarin and a bit of white for the coolest red of the blossoms on the top right. For the center flower, the warmest red so far, try Cadmium Red Light and Alizarin Crimson. The apple to the right side is a warm red. Try Alizarin and black for it. Use various combinations of black, red and Alizarin for the vase.

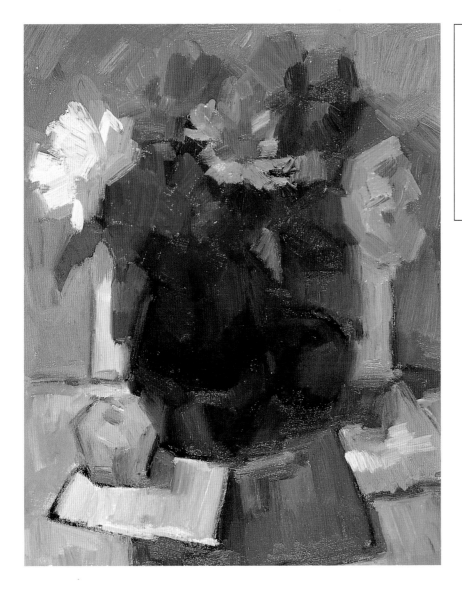

Continue to cover the canvas with flat, simple shapes of color spots. For the background on the top left portion, try green, black, white and Yellow Ochre. For the tabletop, try white, red and Yellow Ochre. For the middle dark folder or mat, try black, Cerulean Blue and white. Add Alizarin for the reflections on the folder.

Step Three

Cover the Canvas With Color

Continue to cover the canvas with simple shapes of color spots. Relate lights to lights, darks to darks, checking values and color temperatures.

It's important to cover the canvas as soon as possible so you can make better judgments about the colors, values and their distribution. The plain white of the canvas or even the underpainting can cause an inaccurate judgment of the color spots that are next to it.

Continue to make comparisons and refinements to the color spots until you are satisfied you have done all you can. Sometimes I paint color into color to make changes, and sometimes I scrape off what I have done if that doesn't work.

It's important not to try to do any finish work now. It's silly to finish an area until you are certain you won't have to change it later. It's too hard to get the courage to remove a part of

the painting you have spent a lot of time on. Besides, if it is wrong now, it will still be wrong after details are added!

You can, however, soften some edges if you have to stop painting for more than a few minutes. Later on, you can always make some edges crisper if you want to, but it is not as easy to soften them once the paint begins to dry.

Stop! Is Your Flower "Growing"?

Sometimes, in fact often, when you are painting a flower and trying to get the shape just right, the flower starts to get bigger and bigger. What should you do? Just "cut into" the contour with a paint-filled brush, starting at the edge or where you want to correct it and paint away from the flower.

You may need to scrape off a bit of the underlying paint first, but the important thing is to use a lot of paint and lay it on lightly. Then wipe the brush well before you make another stroke. Get used to pushing the paint around like this. After all, this is one of the great things about oil painting.

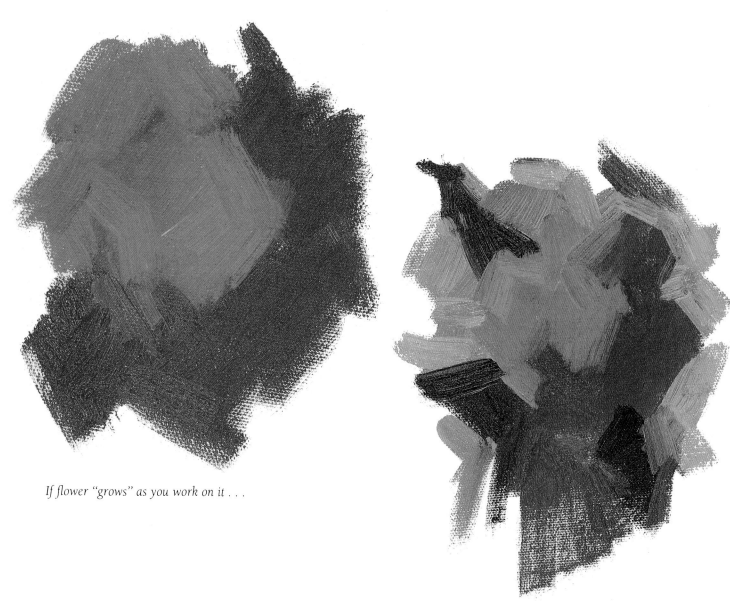

If flower "grows" as you work on it . . .

. . . just cut into it with the surrounding color.

1. Start the stroke where you want to reestablish the contour and stroke outward.

2. Use lots of paint!

3. Wipe the brush after each stroke to keep from messing up the color.

Step Four
Model the Form

This step, the middle stage of the painting process, probably requires the most time and thought. In this step, we attempt to give the illusion of three dimensions on a two-dimensional surface. This takes practice, and you will develop your technique for it in time. Sometimes, it's enough simply to do a little blending where the light meets the shadow, but with some colors, it is necessary to paint in a transitional halftone that is a color between the light and shadow side of an object. For example, the transitions between the warm red and the cool red on the peony and between the warm green and the cool green of the apple can be shown by blending. Remember to use a light touch!

However, the transition between the light and shadow side of the white flower will probably need another color, such as a richer, warmer yellow or orange. This is because when you blend the light side, which is orange and white, with the shadow side, which is blue and white, the result of the blending will be sort of gray and white. In reality, there's more intense color where light meets shadow than the gray that blending produces.

It is during this stage that I like to hear a lot of scraping going on in my classes because then I know that students are making lots of mistakes. That means they are trying new things and learning a lot. Don't be discouraged if the second try is even worse than the first. The next or the next will be better.

Also during this stage, put in reflected lights, make gradations and harmonize colors, perhaps blending

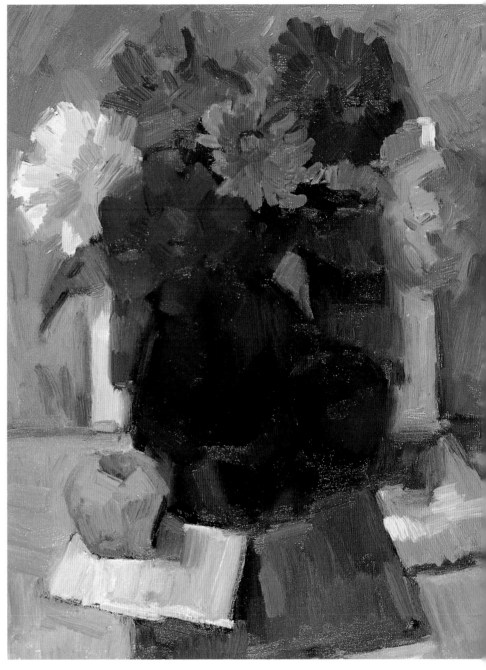

Keep details simple. Notice that the brushwork for the final petals isn't applied until you have a good foundation of form. Also, try to keep them in a pattern and join some of them together; don't just sprinkle them all over the place.

a bit of flower color into the background. Remember to check for a variety of edges.

Notice that the final details aren't put in yet!

Step Five
Details

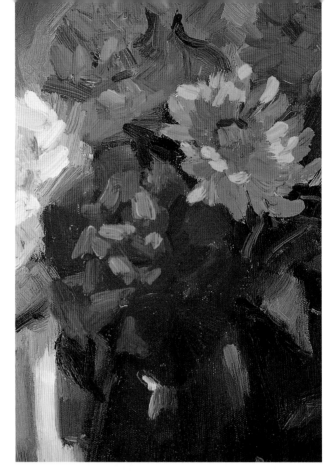

At last! You can now put in petals, leaves, stems, highlights and calligraphy lines to guide the viewer's eye around the painting and accents in the final stage of the painting process. The flower, or flowers, that occupies the focal point, or center of interest, will have slightly more finish, or detail, than other areas of the painting. It is up to you to decide how much detail you want in your painting. I like to allow the viewer to participate in the painting by leaving something to the imagination. I don't necessarily know how much to put in until I have done too much, so then I just take some out.

Keep details simple. Notice that the brushwork for the final petals isn't applied until you have a good foundation of form. Also, try to keep them in a pattern and join some of them together; don't just sprinkle them all over the place.

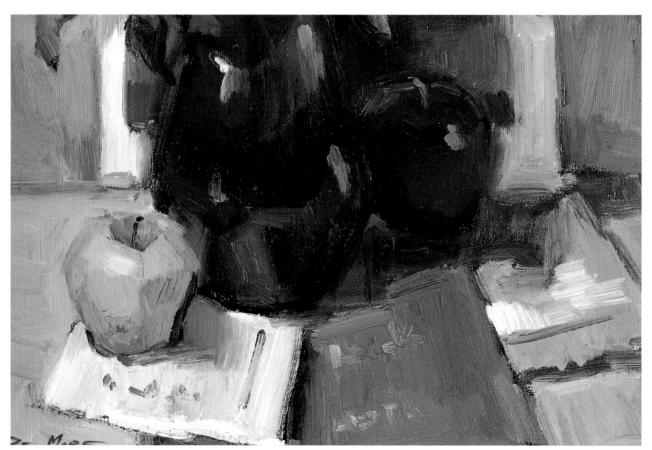

Notice the variety of edges. They are hard where the light pamphlet meets the dark one and lost where the dark red apple becomes enveloped in shadow.

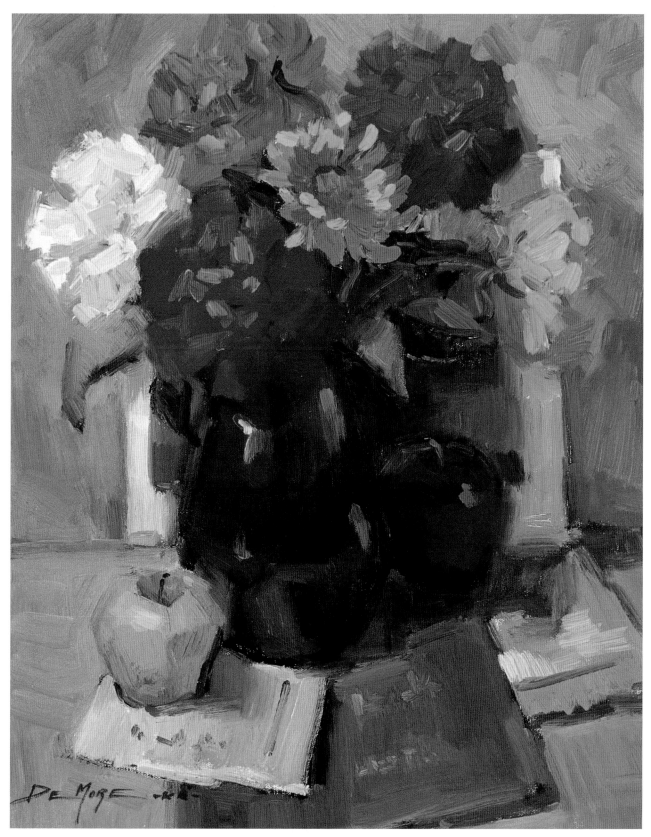

This is my finished painting. How do you know when you are finished? Listen to your intuition. If it feels like it needs more finish, it probably does. Look at it, let it sit awhile, get a mirror, try something, scrape it off and try again. Then you can sign it!

BLOSSOM BUDDIES
20″ × 16″

A Still Life With Warm Earth Tones

A trip to the produce department at the local grocery store is one thing that inspires me. My interest isn't in the cooking part though. The variety of rich, earthy colors is astounding. There is a certain underlying harmony. I'll bet you could put anything together and it would make a beautiful painting. The combination I have chosen for this demonstration is a warm red and orange dominance with touches of blue and green for cool balance. This painting is a rich low to middle key.

When I arrange objects for a still life, I take plenty of time, and you should too. Stand back and look through your fingers or a viewfinder so you can tell how the arrangement will look from the easel. Remember, the photograph really gives little indication as to what the painting will look like. It's only to show the arrangement.

Setup for Garden Goodies. *Take plenty of time when you arrange objects for a still life. Stand back and look through your fingers or a viewfinder to see how it will look from the easel.*

Step One

Draw in Shapes

Often, during the drawing stage, I make changes in the setup to correspond to the way I want the design to look in the painting. The knife in the foreground gives a nice horizontal stabilizing effect and slows the eye's travel directly into the painting.

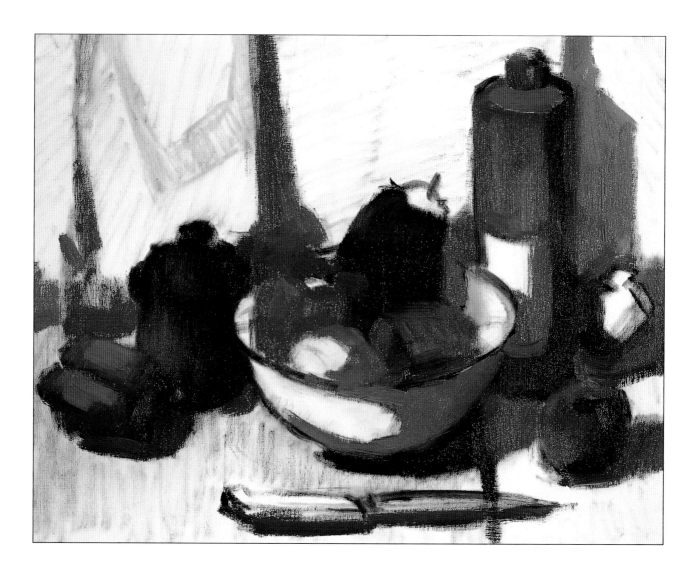

Step Two

Lay in Darks

Scrub in the dark, rich colors, allowing them to connect with one another wherever you can. This is another device that encourages the eye to travel around the painting, and it also gives unity to the design. Notice that each dark is a different color, corresponding to the object it describes; none is just a nondescript muddy black. You are working in the first stage of the painting process in this step and step three.

Lay in the dark colors. Here are some color suggestions for you to try: Alizarin, black and red for the eggplant; Alizarin and Cadmium Red Light for the red pepper in the bowl; Burnt Sienna and Yellow Ochre for the left side of the bottle, adding green to the right and black to the extreme right of the bottle; white, Ultramarine Blue, black and Alizarin for the shadow of the bottle; Yellow Ochre and orange for the onion; Ultramarine Blue and black for the dark jar to the left; Cadmium Red Light and Cadmium Orange for the red pepper on the table, with Cadmium Red Light, Alizarin and black for the shadowed side.

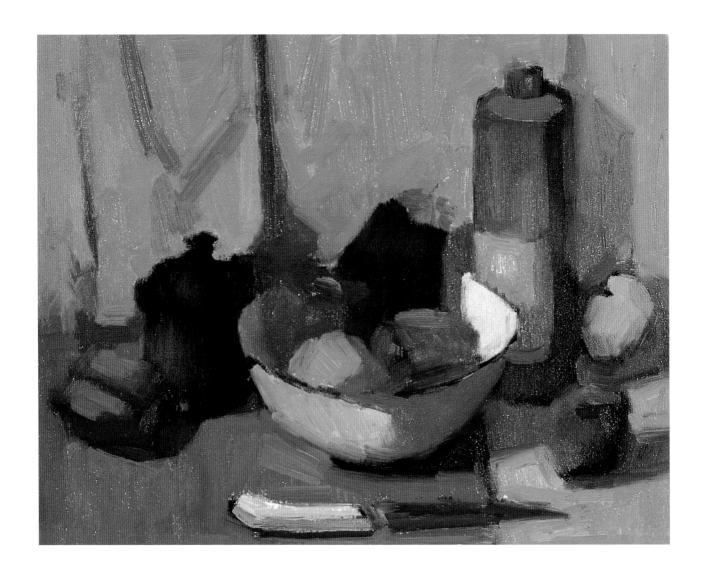

Step Three
Paint in Lighter Values

Continue to cover the canvas as rapidly as you can, working up to the lighter values. Notice that even the whites are all different colors. Also notice there is a balance of similar (but not the same) colors in the painting. Every spot in a painting should be a different color, even if only slightly different. The same piece of cloth will look different in different areas because the light will shine or not shine on it from different angles and different distances.

Compare different color spots as to value, intensity and temperature. For the background in the middle, try Burnt Sienna and white and add Yellow Ochre. Use green, red and white for the background to each side. Use green, yellow and Yellow Ochre for the green apple. For the lighter area of the table on the right, use white, red, Burnt Sienna and Yellow Ochre. For the inside of the bowl on the right, use white, yellow and Yellow Ochre. The green pepper in the bowl is green, black and white. Try white and orange for the handle of the knife and Cerulean, black and white for the shadowed underside of the handle. For the tabletop on the left, try Burnt Sienna and red.

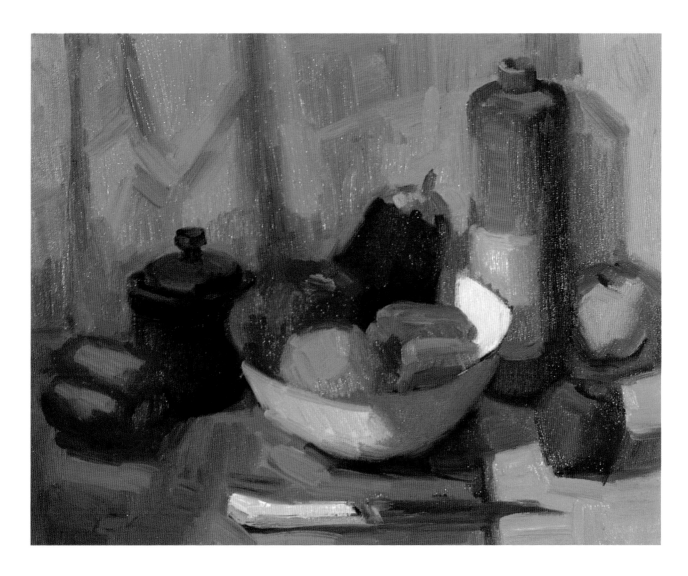

Step Four

Model the Form

Since the colors in this painting are very rich, it is possible to make the objects look round by doing some light blending where the light meets the shadow. The white bowl, however, needs a stroke of white with a bit of orange and Yellow Ochre next to the shadow before blending. Also, notice the touch of green on the tall jug where the light meets the shadow.

When considering the shape of the peppers, you can pretend they are cylindrical with a dent in the side or, perhaps, a double cylinder. But try not to lose the feeling of the main cylindrical form. Even the drape has some feeling of form, which is suggested by the light and dark passages. Notice the green transition color on the tall vase. The middle stage of the painting process for this painting is now complete.

Step Five
Details

When you place highlights for the final or finishing stage, several things are important to remember: Highlights are never just pure white, but each is a different color, depending on the object it's on. Also, the color of the light has a definite influence. Prepare the area under where the highlight will go by finding a transition color that relates to the surrounding color and blending it with the lightest spot as it turns away from the light. For example, on the little blue jar, mix a lighter blue, which tends toward greenish as it comes into the yellowish light. Also, notice the large pinkish highlight on the eggplant and the softer one on the onion. Remember, as an artist, you have the option to make some highlights less important than others if they should take away from the center of interest.

Detail. Notice the variety of edges within this small area.

Detail. Notice the different colors and treatments of each highlight. Highlights are never just pure white. Each is a different color, depending on the object it is on.

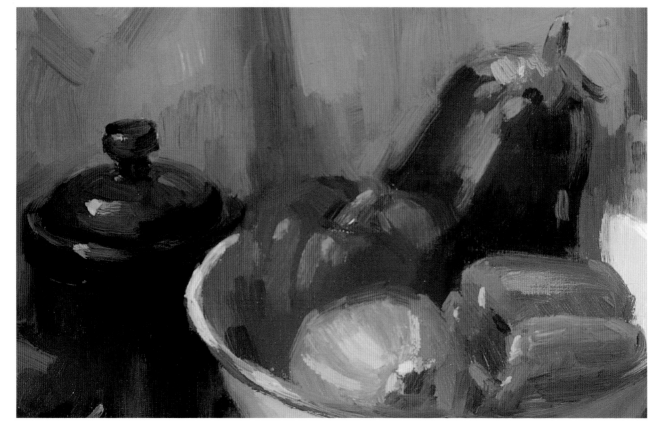

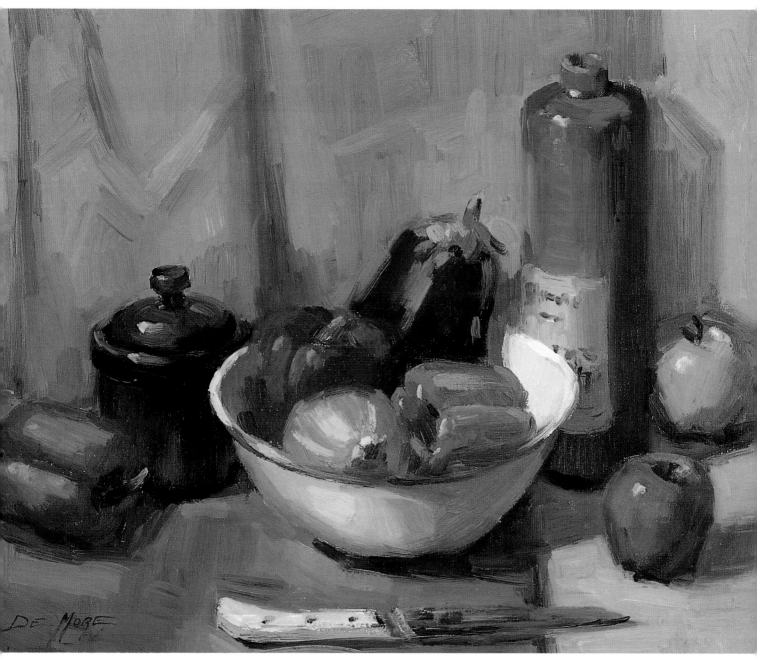

This is my finished painting. Notice the large pinkish highlight on the eggplant and the softer one on the onion. As an artist, you have the option to make some highlights less important than others.

GARDEN GOODIES
16" × 20"

Painting Primer: Simplifying Lilac Shapes

A lilac seems like a confusing flower
until you break it down into a more
simple shape. Look at a lilac as if it
were a cone on the end of a cylinder.

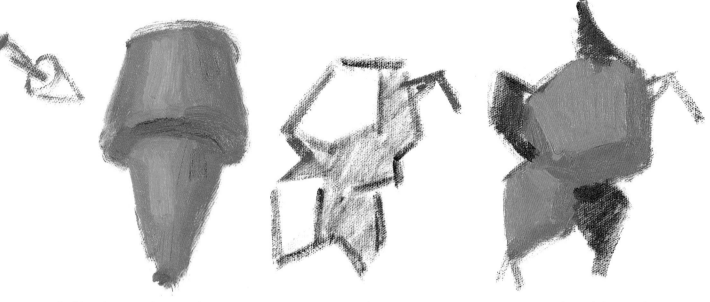

The lilac shape can be viewed as a cone or a cylinder.

Step 1. Draw the silhouette.

Step 2. Paint light and shadow shapes.

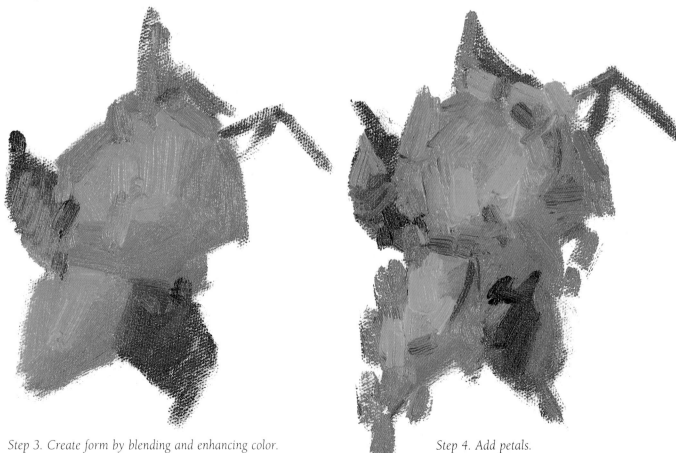

Step 3. Create form by blending and enhancing color.

Step 4. Add petals.

Create Cool Harmony in Warm Light

For this demonstration, I chose lilacs in a basket with a dominance of lavenders and the complementary hues of yellow. These hues are found on the opposite sides of the color wheel. Colors in this setup range from cool, almost blues, in the shadows of the cooler lilacs, to the very warm red-violets, in the lights of the warmer lilacs, and the rich, almost red color of the peony on the right.

I chose objects that are fairly light in value. The canister and the dark red peony are the darkest objects, but neither is extremely dark. This results in a high-key painting. It can be diffi-cult to make a high-key painting read well since the value contrast is limited. You must exaggerate small areas where light meets dark to remedy the limited value contrast. That's what we'll do in this demonstration.

I wanted the arrangement of this still life to look casual. I was careful, however, to place the lightest and darkest flowers next to each other, to create a well-placed focal area. I also placed the cloths and the booklet in a manner so lines would draw the eye into the painting and so these items would help divide the painting into unequal and interesting shapes.

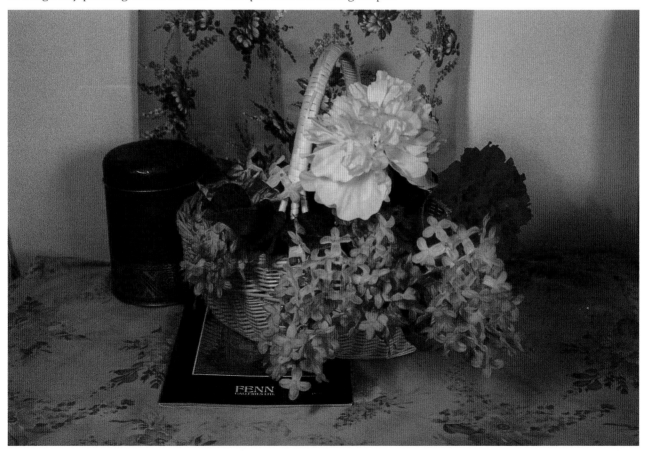

Here is a photo of the setup. Remember, any photo is for reference only. We cannot make a beautiful painting by merely copying the limitations that a camera, film and developing impose on a subject. This setup has a dominance of lavenders and the complementary hues of yellow, which are found on the opposite sides of the color wheel.

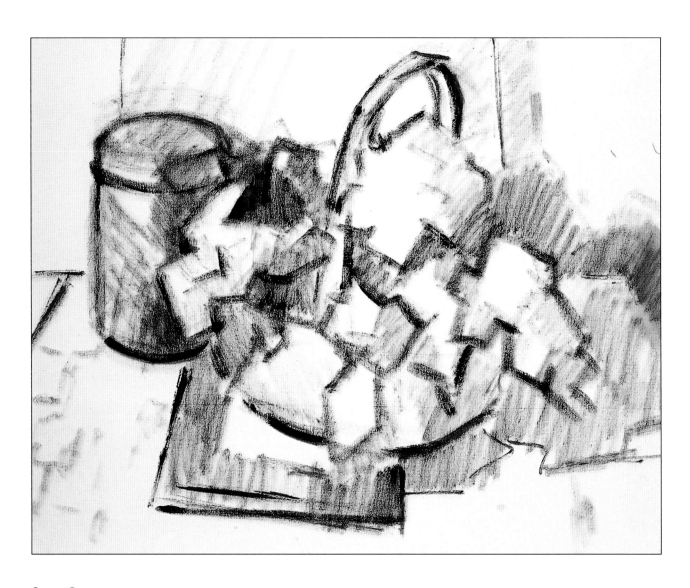

Step One

Draw Unequal and Interesting Shapes

Notice once again that placement, dividing the canvas into unequal and interesting shapes, is the first important thing to consider preliminary to painting. Simplify the lilacs into conical shapes using straight lines so you don't get too fussy and detailed. This also helps retain the design quality and character of the lilacs. Don't let the black paint become runny by using too much thinner. Give only a sketchy indication of where the darks will go so you can judge their distribution and balance.

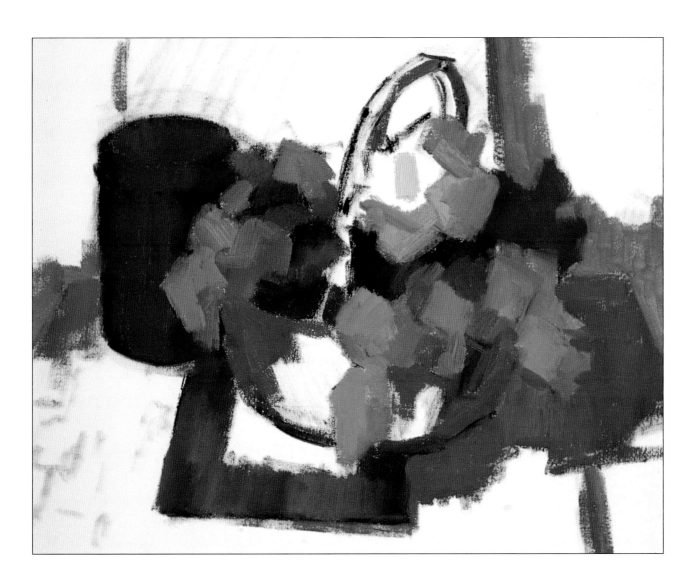

Step Two

Begin With Darks

Once again in this first stage of the
painting process, begin with the
darks, this time starting with the rich,
cool red peony on the right, then go-
ing to the warmer, slightly duller can-
ister. Next, compare the lavender col-
ors of the lilacs and the blue-violet
border of the brochure.

Step Three

Achieve Delicate Color Mixtures

Finish covering the canvas by placing the lights and the large spots of color. You will need to wipe and clean your brush often to achieve the delicate color mixtures that are necessary in painting this arrangement. The clean brush ensures the mixtures will be clean. Also, lay the paint on with a light touch and fairly thickly so other colors won't be picked up and muddy the clean ones. Use a clean brush for blending between areas of drastically different colors. Now is the time to check the relative values and color temperatures of the spots and make adjustments if necessary.

Check the placement and drawing again, and make sure the flowers or objects haven't grown into large blobs. If this happens, just cut into the outside edge of the growing thing and reshape its silhouette as discussed on page 54.

The harmony should be working already. If you squint at the painting, it should give a pretty good impression of a basket of lilacs under warm light even though no modeling or details have been done.

as discussed on page 54.

Cleaning Brushes

1. Wipe the brush with a paper towel to remove the excess pigment.
2. Swirl the brush in a pint jar that's about two-thirds full of turpentine.
3. Wipe the brush with a paper towel.
4. Swirl vigorously in the turpentine again.
5. Wipe with paper towel.

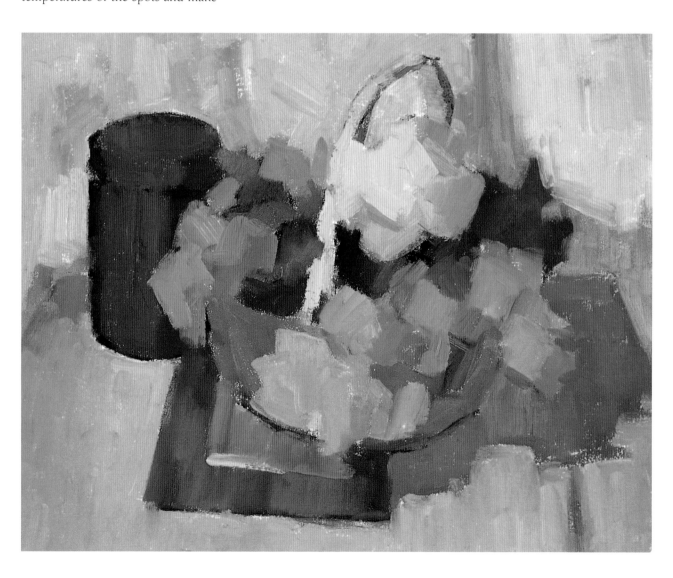

Step Four

Model the Form

Sometimes, this step in the middle stage of the painting process only requires a little blending where the lights meet the darks and maybe just a little softening or firming up of some edges. Sometimes it's necessary to mix another richer color for blending where light meets dark, such as in the colors on the light peony.

Don't worry if you don't get this perfect right away; just carefully scrape off your mistake with a small painting knife and try again. If you still don't feel satisfied, just leave it and go on to another area. *Don't* be too picky right away. *Do* have fun and continue to try things and make mistakes. The only way to improve is to do lots of painting.

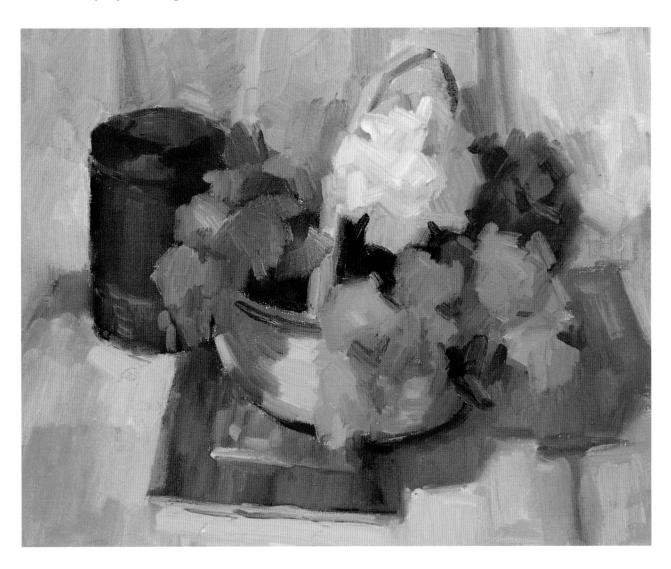

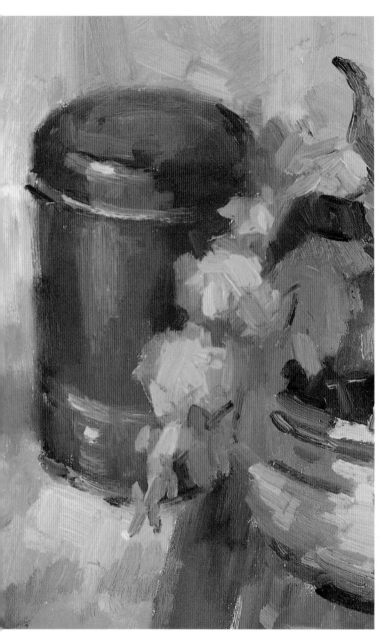

Detail. Notice that when the highlights appear, as on the canister, they are softer than when objects are in a strong light.

Detail. Notice that the leaves have cool lights and warm shadows. In addition, the texture on the basket is soft and has a greenish cast.

Step Five

Details

At last the final stage, you can put in the petals, stems and highlights. Suggest the weave of the basket with just a few strokes. You can also add accents where they seem needed—maybe within the lilacs or under the basket so it sits firmly on the table.

Step Six

Is It Done?

Now here is something to think about. When is a painting finished? This one seemed OK as shown here, but I was fascinated by the pattern in one of the cloths and felt that detailing it would add a positive note to the painting. A change at this time needs to be done subtly, with not too much change in value, so it doesn't take away from the center of interest, which in this painting is the bouquet. Sometimes it's easier to do this when the paint is still wet. It's tricky but is worth trying, and you can always take it out if it doesn't work.

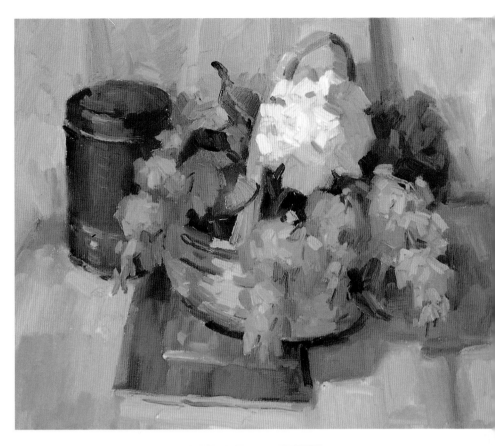

This is a detail showing the pattern that I decided would add a positive note to the painting.

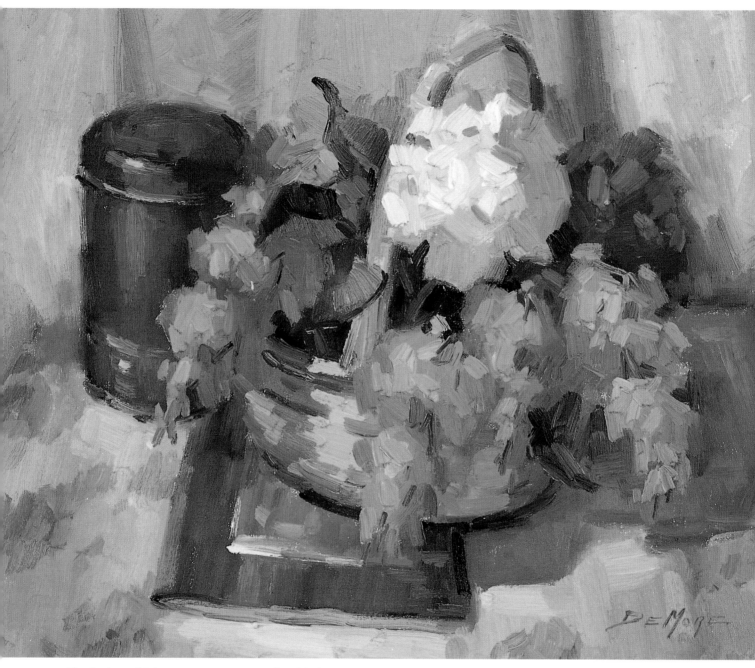

The Basket of Lilacs *set up in warm and cool light provides a good study in comparison of color harmony.*

BASKET OF LILACS
16″ × 20″

A Comparison in Color Harmony Caused By the Influence of Cool Light

After I finished *Basket of Lilacs* and turned out the light, I noticed the beautiful harmony that occurred under the influence of the cool, north light from the window. I decided this would make an excellent example for comparing the differences in color harmony. I've included the photos of both setups here so it's easier to compare the two.

When a subject is illuminated by cool light, the colors on the light side of the objects will tend to be cool, while the colors in the shadows will tend to be warmer. Also, the value differences between the lights and shadow areas will tend to be less and softer than when the subject is lit with a bright, warm light.

Be aware that the warm light in the first setup is coming from the left, but in this setup, the cool north light is coming from the right. You can even see the difference in the overall color of the photo of the still life.

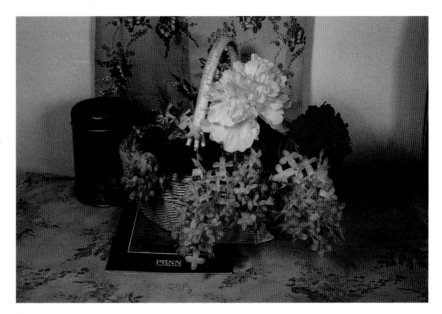

Warm light

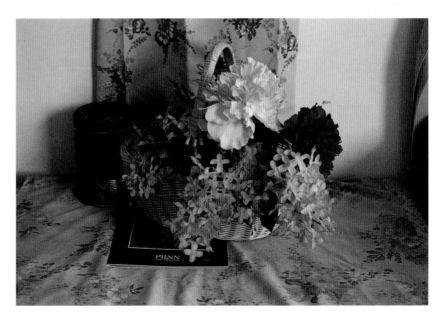

Cool light

Step One

Lay in Color Spots

Begin the drawing as before, and then lay in the simple color spots in the first stage in the painting process. Notice that this time the shadows will be warmer than in the other painting. For example, study the far left-hand lilac portrayed in both paintings. Its local color can be described as a red-violet, but in the painting in warm light, the shadow side is cooler than in the painting in cool light. The light side is warm, almost a light red-violet, in the first *Basket of Lilacs* demonstration, and in this demonstration, the light side is cooler.

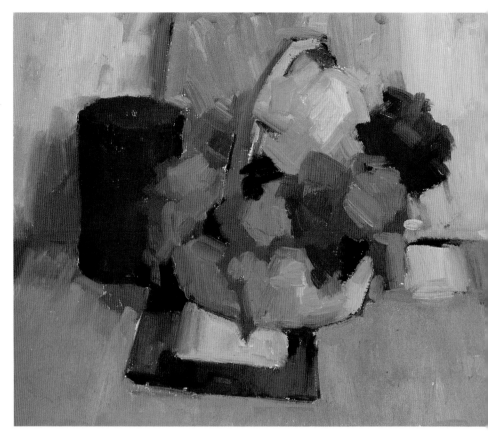

Step 1.

Step Two

Refine Color Spots in the Middle Stage

Refine the color spots, noticing the bluish notes on the cloth, background and flowers. Also suggest form, by blending, except on the light peony, where you need to find the subtle transition color, or halftone. Notice that the basket has a greenish cast in the light and a warmer, more orange cast in the shadow.

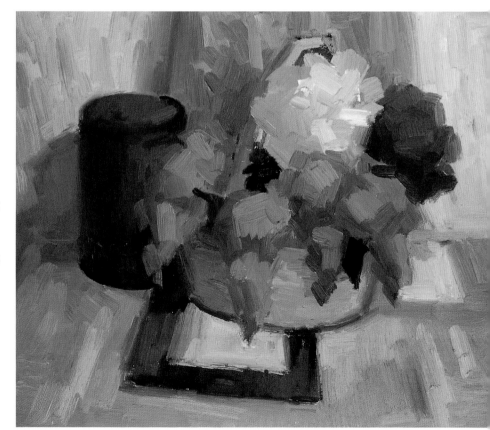

Step 2.

Step Three
Highlights: The Final Stage

Finally, put in the lightest, coolest petals on the lilacs. Some of the petals are almost pure blue and white. Also, the lights on the dark red peony are quite lavender. The highlights are quite soft. Notice how soft and blue the final accents are.

Here is Basket of Lilacs *in warm light for you to compare with* Cool Lilacs.

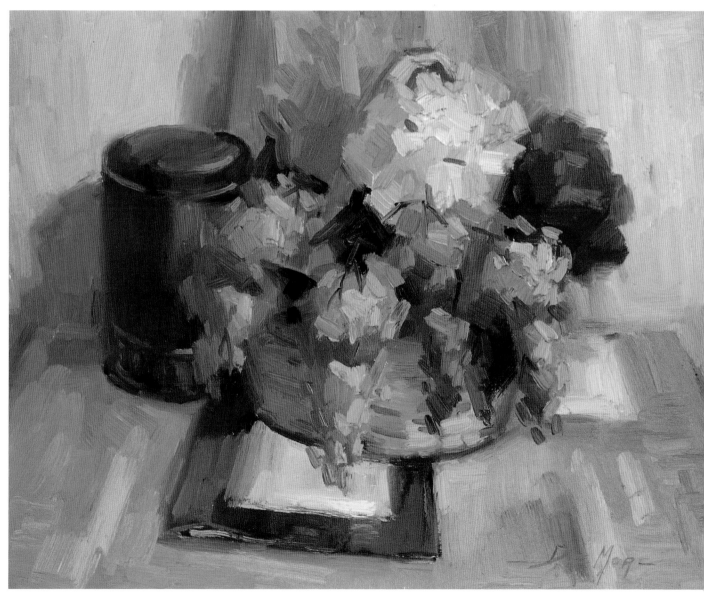

COOL LILACS
16″ × 20″

Crop a Painting

The flowers and objects in this demonstration range from red-oranges to oranges to yellows, which are next to each other on the color wheel. Notes of blues and blue-violets from the opposite side of the wheel are also included. This means there is an analogous harmony of warm colors with a complementary balance of cool colors.

For variety, this time I used a slightly larger canvas size with a different proportion. You can keep it smaller and more simple by cropping and painting only a part of the picture. There are several ways this setup can be cropped and still make a great little painting. I give you a few ideas here, or you can use your viewfinder to find your own satisfying composition.

Remember, the color of each object is influenced by whatever it is next to, so if you are copying my composition, don't move things around. It's perfectly OK to set up your own combination, though. In fact, I would encourage you to do this whenever you can.

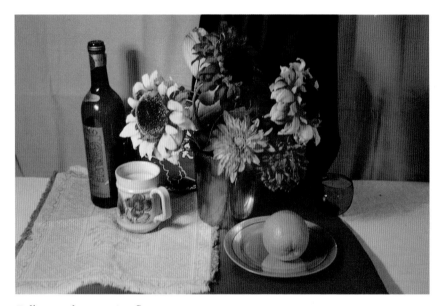

Full setup for Fun Sunflowers.

Possible ways to crop the original setup. Look for more with your viewfinder.

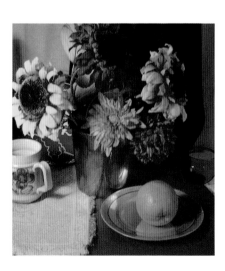

Step One
Draw in Shapes

Make a careful drawing, trying to get the character of the sunflowers without getting too fussy. You will notice I took artistic liberties with the little blue bowl because I thought it made a better shape and size for variety in the composition.

Step Two
Lay in Darks

Lay in darks first, comparing blues to blues and oranges to oranges. Ask yourself, "Is this spot warmer or cooler than another spot?" and so on. This step and step three are in the first stage of the painting process.

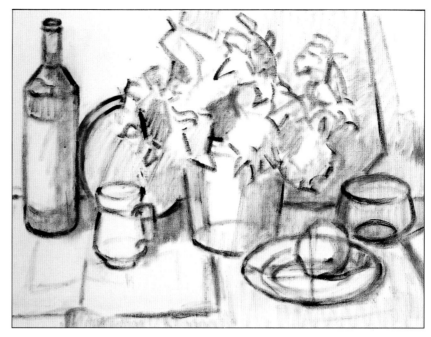

Step 1.

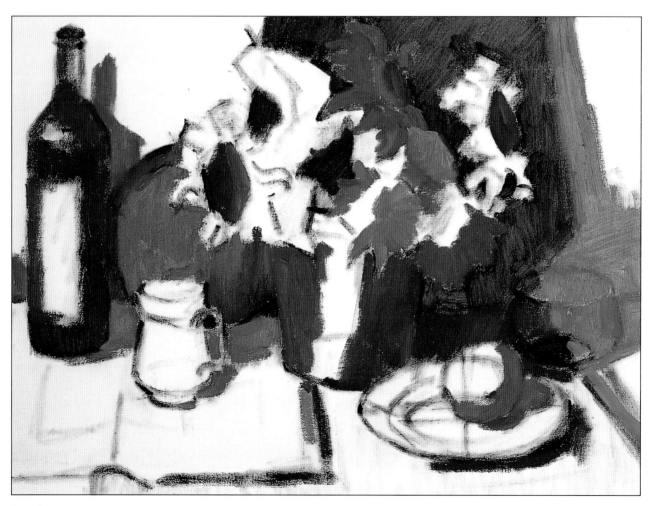

Step 2.

Step Three

Cover the Canvas With Color

Cover the canvas, working your way to the lighter and more subtle colors. Avoid the very lightest lights and details. I changed the shape of the orange cloth in front because I just felt it looked better this way. Remember, painting is a process of improvement. Don't be afraid to go ahead and change things.

Notice that I also put in only the shape of the petals, not the individual petals.

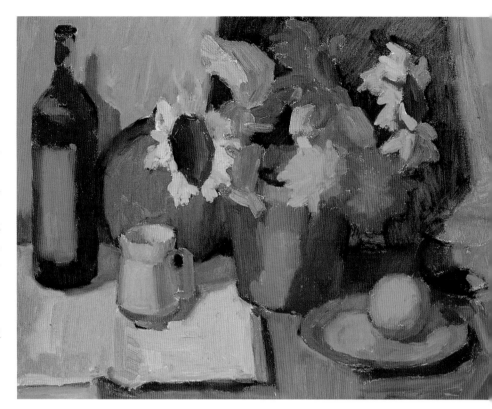

Step 3.

Step Four

Model the Form

In the middle stage, keep the glass objects and the copper simple. Don't put in every tiny spot you may see. Stand back after each stroke you add and see if what you have on your canvas "suggests" the object.

An effective technique to suggest the quality of copper is to make a spot of light or dark more firm on one side and soft and blended on the other side. Notice that the light blue cloth has light and dark, which must be blended to give it form.

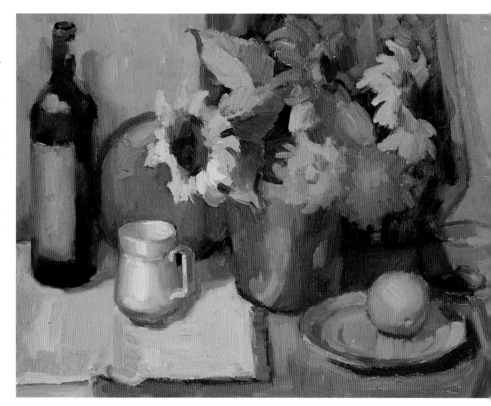

Step 4.

Detail. This detail shows a few petals, as well as where the dark centers of a couple of the sunflowers are lost in the dark background. Notice that this part would make a nice painting itself (without the cup in the corner).

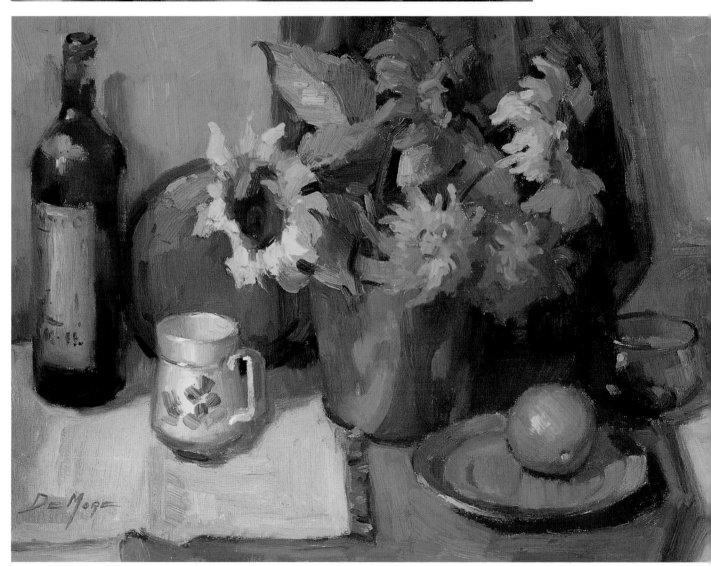

Step 5.

Now you can put in the brightest petals, highlights, the pattern in the little cup, the writing on the label and other details.

FUN SUNFLOWERS
18″ × 24″

Painting Primer: Tulips

When you paint tulips, think of them as shaped like a cup, or a hollow half-sphere. In order to really understand the shape, you can hold a cup so it catches the light from different directions.

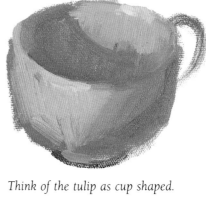

Think of the tulip as cup shaped.

Step 1. Draw the silhouette.

Step 2. Block in shadow and bright spots.

Step 3. Give the tulip form by softening the area where light meets shadow.

Step 4. Suggest petals and complete details.

Painting Primer: Daisies

Daisies are shaped similar to a saucer. Sometimes the saucer is turned inside out. You don't need to paint each petal. In fact, it is better to paint at least part of the flower as a solid shape.

Think of the daisy as a saucer.

Step 1. Draw the silhouette.

Step 2. Block in shadow and light spots.

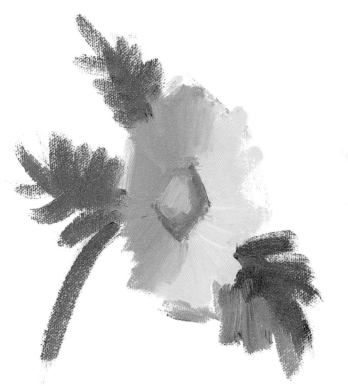

Step 3. Give the daisy form by blending and softening.

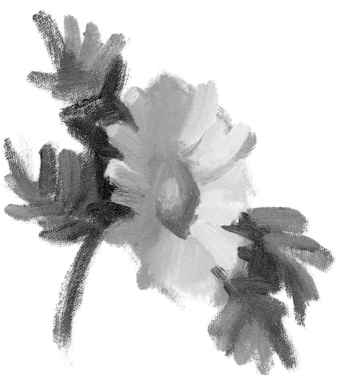

Step 4. Suggest petals, leaving part of the flower solid. Complete details.

Paint Outdoors

Our last floral demonstration will teach a number of lessons. The most important lesson in this demonstration is how to observe and paint the intense warm and cool contrast of outdoor sunlight. The outdoors is filled with intense light, and much of it is reflected light, so objects lose much of what we consider to be local color, or the color we customarily attribute to an object. When you begin to paint outdoors, you will start to see colors you never saw before—a very exciting time in an artist's life.

Setup

I have included a photo of the still life setup and the equipment I used for this demonstration. Notice the large size of my palette and its position out of the direct sunlight and in relation to the still life. It is virtually impossible to paint with the canvas and palette in direct sunlight because the glare will destroy your sensitivity to color.

The photo of the setup does show some indication of cool shadows, but the warm lights are almost completely washed out. You will see when you begin to paint directly from life outdoors that the camera is extremely inadequate. This painting was done two days in a row between the hours of 10:00 A.M. and 12:00 P.M. That is about the maximum time you can spend on one painting because of the changing light. Even at that, you must make a careful note of the shapes of the shadows at a given time, say 11:00 A.M., for consistency. Also, don't expect the light to be the same a week from now; it will be different then, too.

My outdoor painting equipment. Notice my palette is positioned out of the direct sunlight.

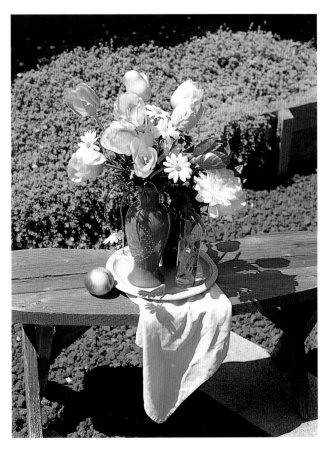

Outdoor setup. This photo does show some indication of cool shadows, but the warm lights are almost completely washed out.

Step One

Draw in Shapes

Make a preliminary, simple drawing, concentrating on placement and shapes of objects and shadows.

Step Two

Start With Shadows

In the first stage, start with the areas that are in shadow and relate these cooler colors to each other. Remember, shadows outdoors are not black but full of color.

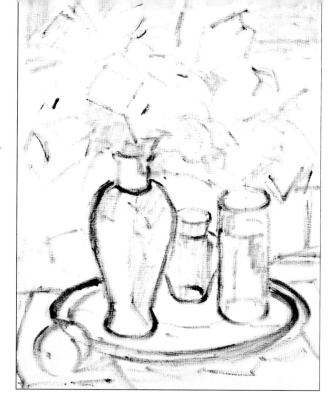

Step 1.

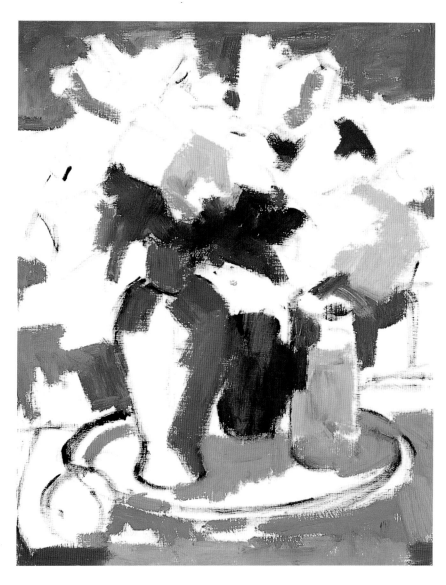

Step 2.

Step Three

Cover the Canvas With Color

Continue the first stage in the painting process by covering the canvas as rapidly as possible, concentrating on the relationship between the warm sunlit spots. It's better to make a quick, intuitive judgment now than it is to spend too much time staring at the subject as the light changes. It's a good idea to take the painting indoors and look at it there to give your eyes a rest. Indoors you can check what changes are needed in color judgments and mixes to achieve the effect you thought you were getting when you were in the bright sun. In fact, it is better to paint intuitively for a short time inside than to continue to paint a subject that has changed completely due to the changing light. You can always adjust it tomorrow.

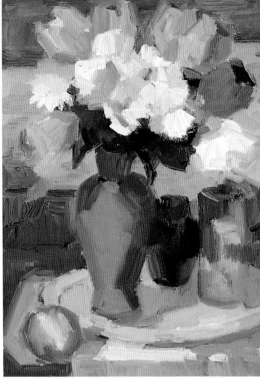

Step 4.

Step Four

Refine Color Spots

Take plenty of time to refine color spots because the feeling of sunlight is the most important thing. Since this is so important, the first stage for this painting is in three steps. You can always check drawing and details later.

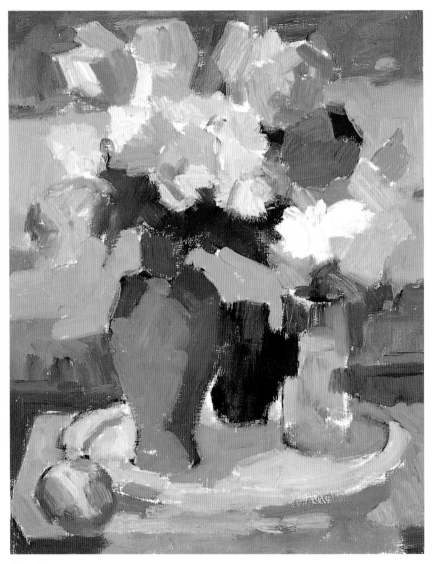

Step 3.

Step Five
Model the Form

Begin the modeling for the middle step with the objects in the lower part of the painting first because the objects demand more precise modeling and placement of shadows than the flowers. The glass vase is done by simply observing the color spots and painting them. Pull the background color in to suggest the see-through quality of the glass.

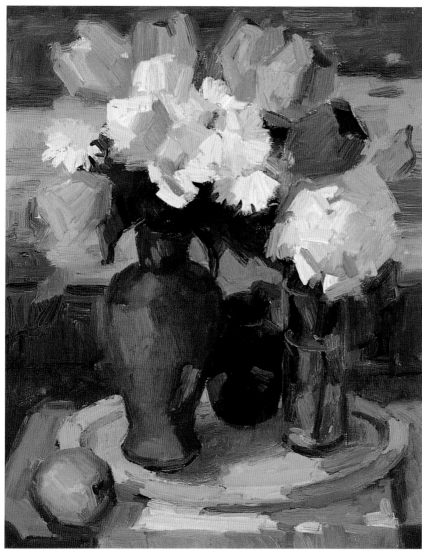

Step 5.

Detail—Glass.

Detail
Glass

There is no one way to paint glass. Just paint the color spots that show through, making them a bit distorted according to the way they are refracted by the water and the glass. Then place a few highlights and brilliant lights near the bottom of the vase.

Notice the softness of the flower next to the hardness of the glass and the little dark vase in the background.

Step Six
Refine Flowers

Now you can give attention to the flowers in this continuation of the middle stage. This includes giving form to the centers of the daisies.

Detail
Edges

Take some time to study this detail and notice the variety of edges of the flowers and their centers and accents. Some are sharp, some are soft and some are lost.

Detail—Edges.

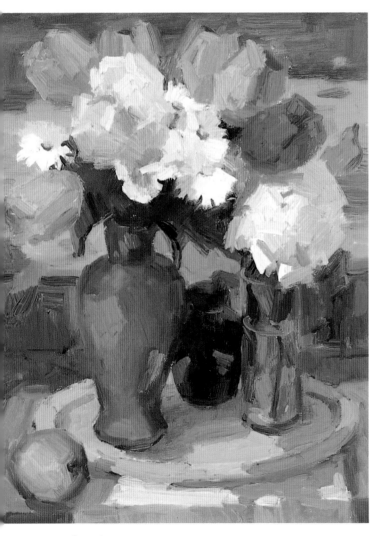

Step 6.

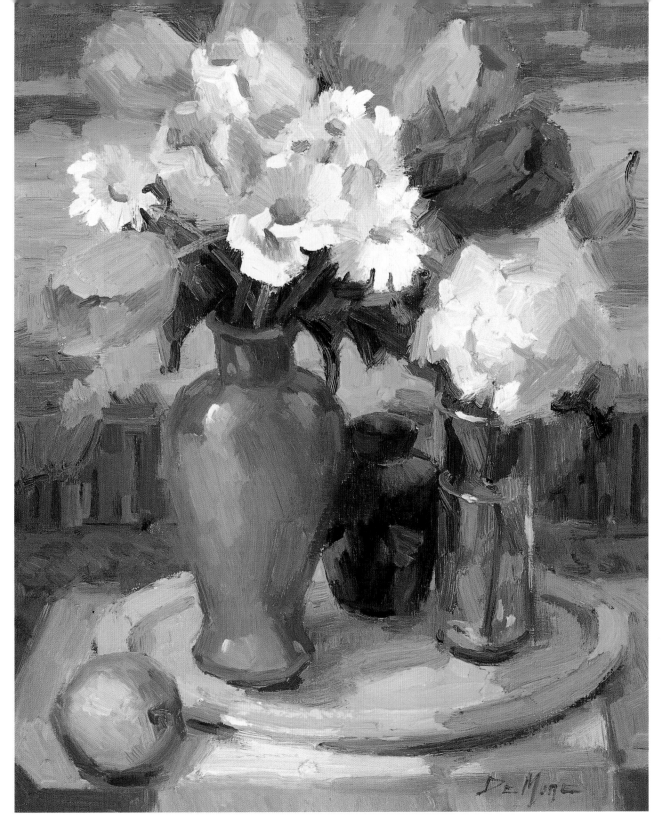

SUNSTRUCK TULIPS
20″ × 16″

Step Seven
Highlights and Details

Finally, it's time for details. Put in highlights on the vases, petals, stems and accents. Also, add a few vertical strokes to suggest the boards defining the garden and a few strokes to suggest the red rocks.

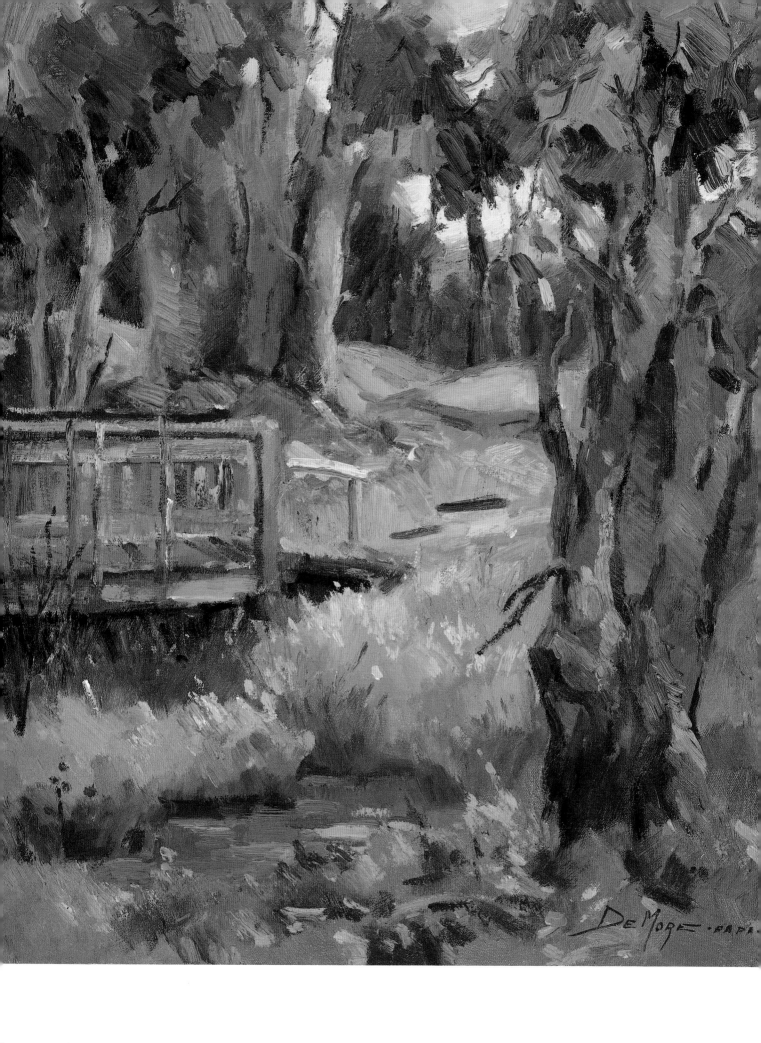

PAINT LANDSCAPES

The Great Outdoors

Now that you are used to using the brushes and mixing up colors and are more aware of color relationships, it's time to have a try at painting landscapes. Landscapes can seem pretty scary at first. All of the complicated stuff around, like trees and leaves and twigs and rocks and shadows, can be intimidating. How do you paint all that? Well, you don't! You just pick one simple subject that interests you and squint down till you see only big, simple color spots. Then get out a big brush and a little canvas and paint those spots. It will be even more important now than before to keep it simple and do it quickly because the light changes so rapidly. You can always put in the details later.

As we progress through the demonstrations, I will show you some ways to paint rocks, trees, clouds and grass and what to look for as you are painting. Once again it's a "play as you learn" game, so have fun.

Sometimes I include photos to show you the location I chose to paint and what inspired me. But please, please don't copy from photographs. You really will learn very little except how to copy the camera's mistakes. It's certainly OK to copy my demonstrations, however, because I have already done some simplification and you can learn from them.

Although I have not toned the canvas in the demonstrations for this book because of the photography, I would recommend that you do this, especially when painting outdoors. Use a little Phthalo Blue and black in a very runny wash of turpentine. Make it fairly light in value, and allow it to dry overnight if possible.

◄

BRIDGE AT SWEET SPRINGS
24″ × 20″

A Few Pointers About Landscapes

The outdoors is flooded with light, a vast spectrum of colors and values we can't possibly duplicate with our limited range of pigments. To compensate for this limited range, the impressionists invented a way to fool the eye into perceiving light and shadow. Instead of attempting to show this contrast with values, they learned to exaggerate the differences they observed between the warm light and cool shadows, just like we have been doing with the indoor still lifes.

Some general rules about landscapes follow. Remember, there always seem to be exceptions:

- ▶ Cast shadows will be much lighter outdoors than indoors.
- ▶ The sky is the source of light, so it is the lightest area.
- ▶ The next lightest area is the horizontal, or ground, plane because it receives the most light from the sky.
- ▶ Slanting planes, such as mountains, are darker than the sky or ground planes.
- ▶ Vertical planes, such as trees and buildings, are the darkest.
- ▶ There is more contrast and the colors are richer in the foreground than in the background.

- ▶ Because of atmospheric perspective, objects in the distance will appear lighter, grayer, flatter and slightly bluish.
- ▶ When you are painting outdoors, often the dark sides of objects and shadows appear darker than they really are. To remedy this, hold up a piece of black paper close to you and compare it to the shadow spot you are observing.

Examples of situations that might seem to be exceptions:

- ▶ Sunlight on the vertical plane of a white or light building might be lighter than a rich blue sky.
- ▶ A shadow on a dark horizontal plane might be darker than a shadow on a light vertical plane.

The two situations above are not really exceptions but the result of all of these factors working together.

Remember, these are just hints to give you an idea of what to look for when you are painting landscapes. The only way to really tell is to observe, squint and compare.

Now, it's time to get started making those mistakes!

Paint Your First Landscape

For your first landscape, choose a subject that is fairly simple. You can avoid complicated perspective problems by keeping the buildings and trees in the distance very small. There is a simple rule to consider when painting clouds. We usually think of objects placed higher on the page as being farther away. This is true when objects are below us. Since clouds are above us, the opposite is true. The larger, closer clouds will be in front of, above and overlapping the smaller more distant ones.

Source

I don't have a photo of the inspiration for this painting. Go ahead and look at the final painting at the end of this demonstration if it helps to give you direction. Notice that this is a high-key, dominantly cool painting.

These little sketches show correct cloud placement. Notice that the closer clouds are higher on the page.

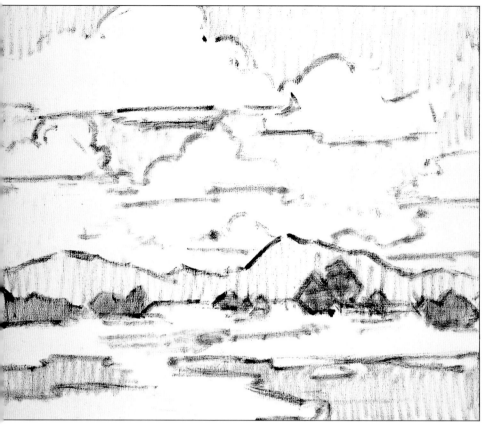

Step One

Draw in Shapes

Place the horizon line fairly low on the canvas, since the sky and clouds are important in this painting. When you plan the painting, remember to vary the shapes and sizes of the clouds, trees, mountain peaks and even the shadows.

Step Two

Scrub in Darks

Begin to cover the canvas in this first stage by scrubbing in the darkest areas first, which in this case are the trees. Then proceed to the mountains, shadows and sky, which are different varieties of cool colors, ranging from greens to blues to purples. This leaves the light sunstruck areas of the clouds and the grassy, horizontal ground plane. Notice that the sky is lighter and warmer at the horizon and darker toward the corners. Exaggerating these differences will help to give the illusion of the domelike shape of the sky.

Here are some color suggestions you can try. Start in the middle of the sky with Cerulean Blue and white. Add green as you approach the horizon, and add yellow and orange near the horizon. Try Ultramarine Blue, Cadmium Red Light and white for the mountains. Use Cerulean Blue, black, green, white and Ultramarine Blue for the dark shading in the grassy plane.

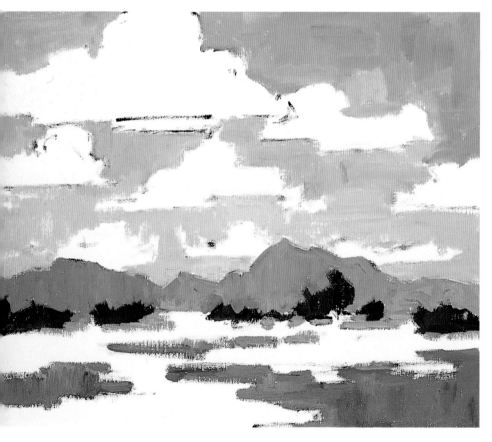

Step Three

Cover the Canvas With Color

Finish covering the canvas by blocking in the warm green of the grassy plane, the cool shadow undersides of the clouds, the warm light sides and the tiny distant buildings. This step is a continuation of the first stage in the painting process.

Mix white, Cadmium Orange and Cadmium Yellow Light for the light side of the clouds. Add more white and yellow for the lightest. Use black and white for the shadow side of the clouds. Use greenish blues that have muddied your palette for the grassy areas in the foreground. Add green and white for the cooler grassy areas in the distance.

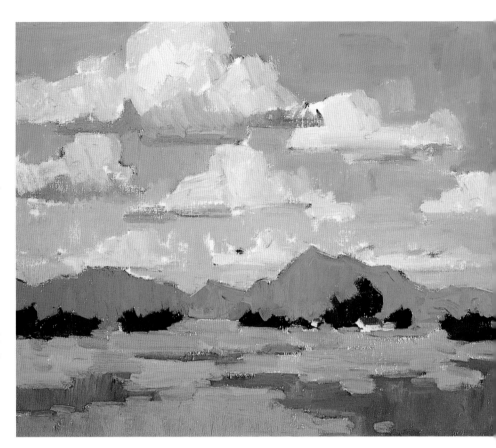

Step Four

Use Transition Colors

As you work to make the clouds look round, you need to introduce transition colors between the light and shadow areas, since the idea is to make an extremely light "white" object look like it has volume. To do this, mix a warm color, such as orange, with white for the light and a cool color, such as blue, for the shadow. Blending the orange and blue together where the light meets the shadow isn't best because they are opposites, or complements, and tend to neutralize each other. This produces a gray at the area that has the most color in nature. See the detail of the finished clouds, which shows the use of the transition colors. This is the middle stage of the painting process which continues in step five.

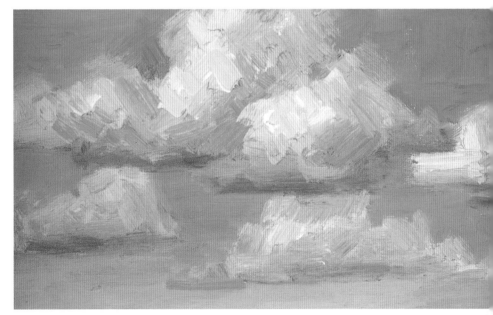

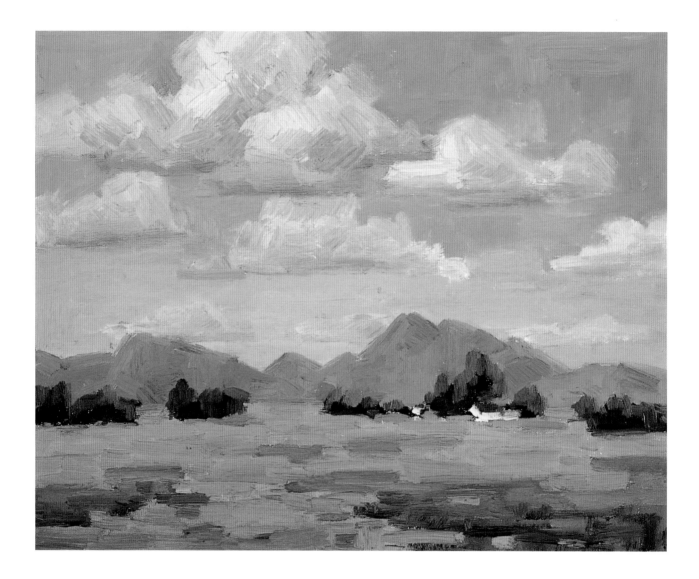

Step Five

Model and Adjust Color

To make the ground plane look flat and recede, add warm color to the foreground, such as yellow, orange, green and Burnt Sienna. Use cooler blues toward the background, especially near the mountains. Ultramarine Blue can be used for shadows.

Make adjustments to color areas until you feel they look right, and soften some edges. Also add a few cool reflected lights on the trees opposite the sun. Try some black and yellow and orange for this.

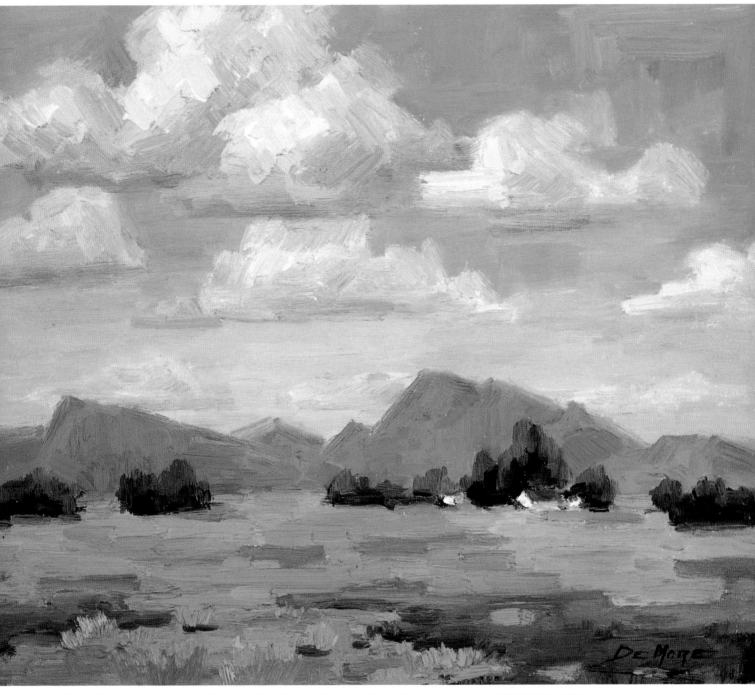

This is the finished painting. Suggest a bit of warmth on the sides of the mountains facing the sun.

LOTS OF CLOUDS
16″ × 20″

Step Six

Details

The mountains are distant and they should remain relatively flat, but they still need a suggestion of warmth on the sides facing the sun, just to give a bit of interest. Try a little Alizarin Crimson and Cadmium Red Light and white to achieve this. A few upward strokes with the side of the brush using yellow and orange and green suggests grasses in the foreground. Also, do a few finishing touches to the buildings. The final stage is complete.

95

Painting Primer: Paint Trees

Here's a short demonstration to show what to look for when you are outside painting trees. Remember, this tree is out of context. The colors and values will be different within a painting because they won't be surrounded by "killer white" canvas.

Think of a tree as having a form similar to a mushroom with lumps or a combination of half spheres.

Step 1. Draw the silhouette. Make one side more interesting than the other.

Step 2. Paint in dark spots and light spots. Leave a few sky holes. Make them darker than the rest of the sky.

Step 3. Give the tree form by blending where light meets shadow.

Step 4. Details. Add a few leaves, and finish the trunk.

More Tree Shapes

Look for character. Try these shapes
and others you observe on your own.

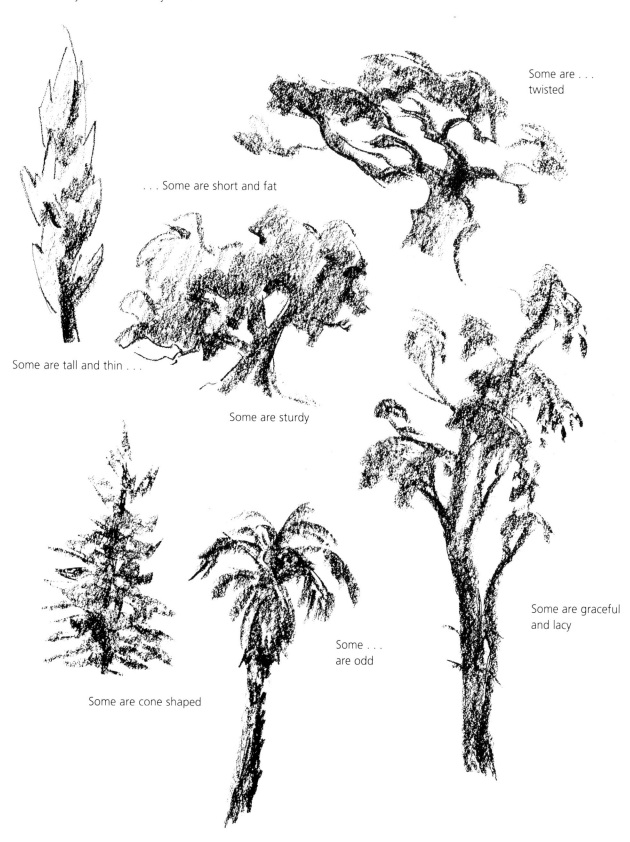

Some are . . .
twisted

. . . Some are short and fat

Some are tall and thin . . .

Some are sturdy

Some are graceful
and lacy

Some . . .
are odd

Some are cone shaped

Create Grasses and Trees

This shows two photos taped together that were the inspiration for this painting. Notice that the photo is quite a bit different than the painting, which is as it should be, since we do not want a painting of a photograph. We want an impression of the mood of a place.

I have always been attracted to grassy, weedy areas. I found the location pictured here just a few blocks from my house. Of course, I took quite a few liberties by rearranging and simplifying the composition for you. I believe even with the changes, I have captured the essence of the place. These demonstrations show you that the painting usually bears little resemblance to the photograph of the scene. You'll find this in your own paintings the more you paint and observe the color spots.

You can use the mushroom shapes of trees that you practiced in the Painting Primer: Paint Trees section here. There is no single way to paint the grass and weeds.

Step One

Draw in Shapes

Place small marks at the edge of the canvas to denote the middle of the top, bottom and sides. These marks will remind you to avoid letting lines go out of the painting at these places. Now,

draw the weed-covered hill, avoiding the centered marks. Next, draw the big shape of the main group of trees. Make it interesting. Continue placing the other shapes, making each successive division, including the sky, unequal and interesting. Notice the foreground diagonal suggests a path that opposes

the main slope of the hill and leads the eye into the picture. Also, notice that the sky shapes and mountain shapes, even though they are negative shapes, are carefully considered. All of these points are part of the important preliminaries to be considered with each painting.

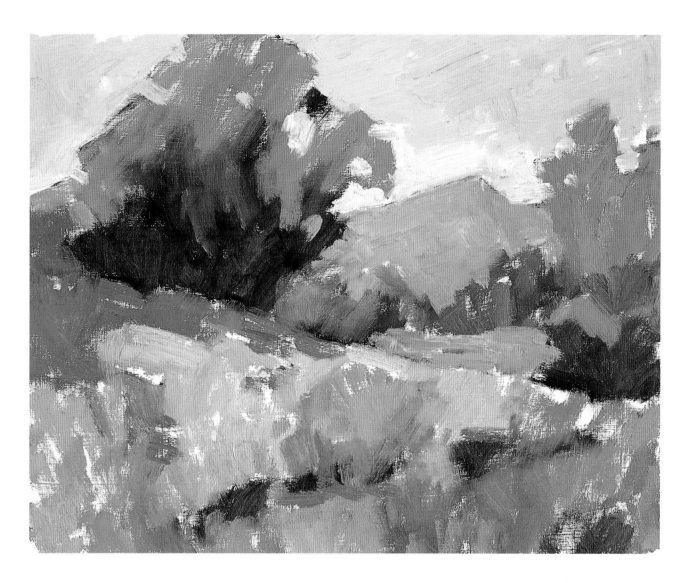

Step Two
Block in Color

Block in color spots very rapidly in this first stage in order to cover the glaring white canvas so you can make better color judgments. To keep the color fresh, don't make too many color corrections now or worry too much about the little specks of white canvas showing through. Just get it all covered, then stand back and squint.

I used Permanent Green Light and Cadmium Orange for the foliage of the tree on the left, and for the trunk, I used Cadmium Red Light, Burnt Sienna and black. For the low sky near the mountains, I used Yellow Ochre, orange and white. Midway in the sky, I used Cerulean, yellow and white with Ultramarine Blue for the top of the sky. Try Permanent Green Light, Burnt Sienna and black for the dark bush on the right and green, black and white for the grassy knoll just beyond it. For the weeds and grasses in the foreground, I used differing combinations of Yellow Ochre, green, Cerulean, black, white, Burnt Sienna and Cadmium Orange.

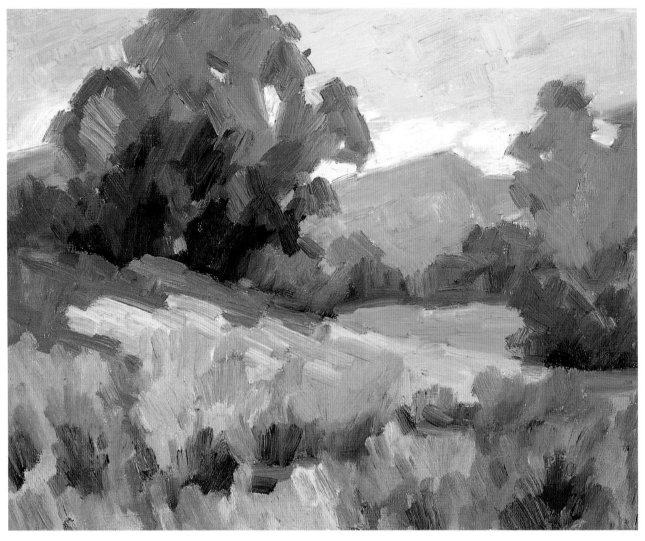

Refine the color spots, paying particular attention to the light and shadows. Cover all of the white canvas.

Step Three
Refine Color

Begin to refine the color spots to continue the first stage. Pay particular attention to light and shadows, playing warm against cool. Notice how the brushstrokes describe the forms: vertical for the grasses, horizontal for the more distant ground and diagonal for the foliage. Also, fill in those nasty little white spots where the canvas shows through.

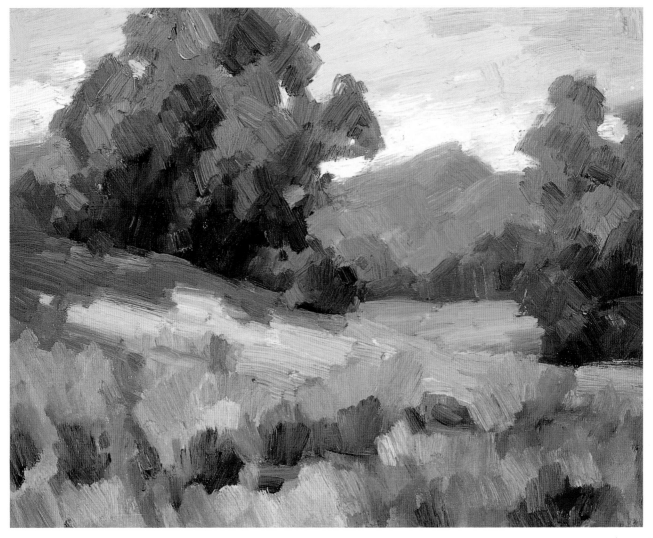

Details. Notice the direction of the strokes that define the foliage and leaves in this detail. Remember, it doesn't take many for that light against dark to achieve the maximum effect.

Step Four

Model the Form

Now is the time to make the trees look three-dimensional, the foreground grasses look vertical and the hillside look horizontal and recede in the middle stage of the painting process. Cool strokes on the far side of the hill and the distant grass will help achieve this effect. Sometimes, it helps to put a slight suggestion of warmth on the light side of the background mountain but not too much because objects become flatter as they recede into the distance. As for the weeds, just make them darker toward the ground and lighter toward the top, playing light against dark. The best way to learn how to do this is experimentation.

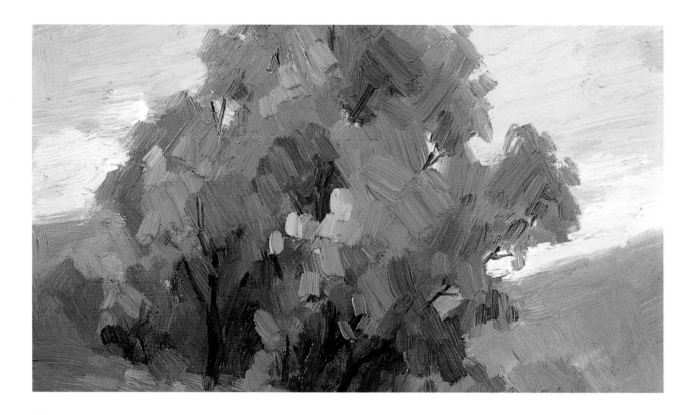

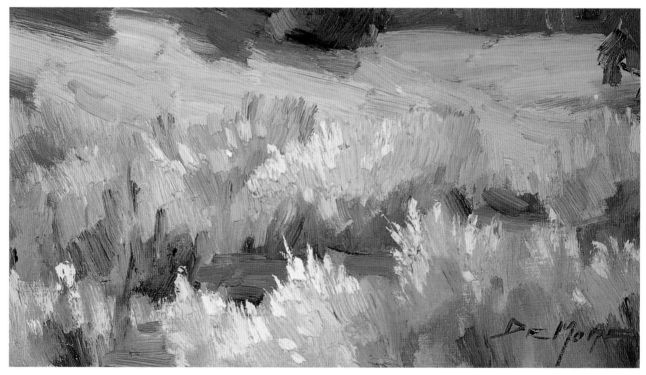

Details. These details show how to define the grasses with dark strokes at the bottom and light at the top, as well as playing the vertical strokes against horizontal strokes of the ground and the hillside. Notice that the highlights, or details, are tied together, not scattered all over the place, and are relatively few. They also show the cooler strokes on the hill and distant grasses.

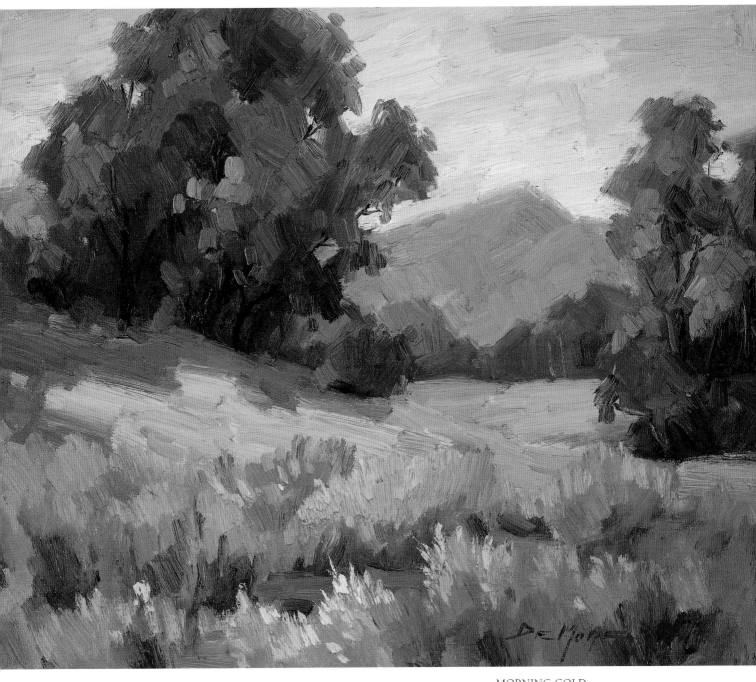

MORNING GOLD
16″ × 20″

Step Five

Details

Place a few leaves as the highlights
on the foliage, a few trunks and
branches, some thick, light strokes to
define the weeds, and you are done
with the final stage, the finish.

Painting Primer: Paint Rocks

The variety of rocks and ways we can represent them in a painting are practically endless. Here are four mini-demonstrations to give you some ideas. It helps to shine a light on small rocks when you draw them.

Step 1. Draw in silhouette.

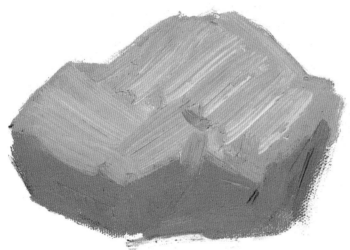

Step 2. Lay in light and dark areas.

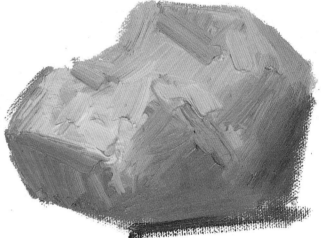

Step 3. Model. Leave some edges of planes rounded, some sharp and some rough.

Step 1. Slash in dark strokes.

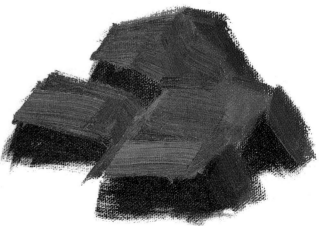

Step 2. Finish with light strokes. Use three or four different colors and values for different planes.

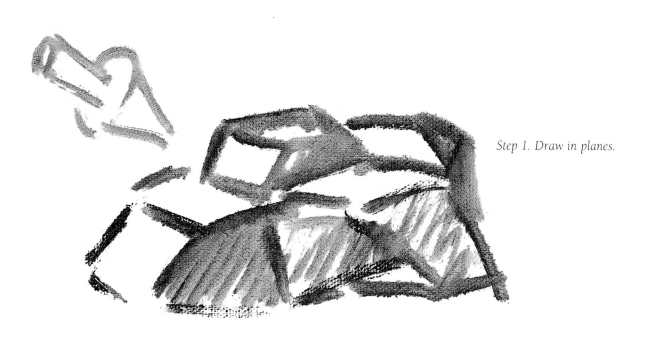

Step 1. Draw in planes.

Step 2. Paint planes that catch the light at the same angle as a similar color. Use three or four different colors and values for different planes.

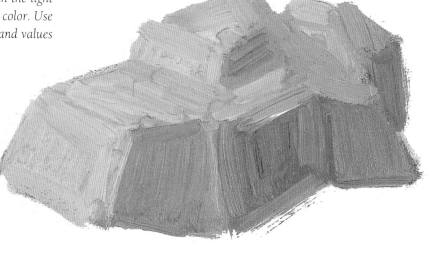

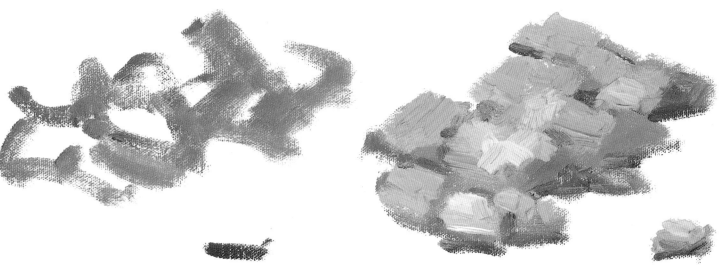

Step 1. Splash in suggestion of darks.

Step 2. Brush in various strokes.

Painting Primer: Paint Reflections

Reflections can be fascinating—in fact, too fascinating sometimes. It's easy to get too fussy or to say too much unless you apply restraint in painting them. As artists, our purpose is to say "water" and to help make an interesting design. Reflections usually work best if they are secondary to the main interest. Whatever you do, please avoid dividing the canvas exactly in half and making the reflections the exact image of the subject.

Some Important Points

▶ The most important thing to remember about reflections is that every point is reflected *directly* below and not off to the side.

▶ The length of a reflection is determined by its position relative to the level of the water and how calm or rippled the water is. In calm water, it will be the same length; in rippled water, it tends to be longer. There is leeway, or "artistic license" in interpreting reflections for the benefit of the design. It helps to simply be outdoors painting and observing, since reflections have so much variety and character.

▶ Reflections are usually slightly warmer than the objects and fall into a narrower value range. The darks reflect a bit lighter and lights a bit darker, their average value being slightly below a midtone.

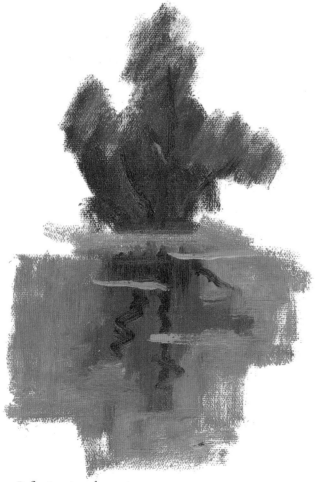

Reflection in calm water.

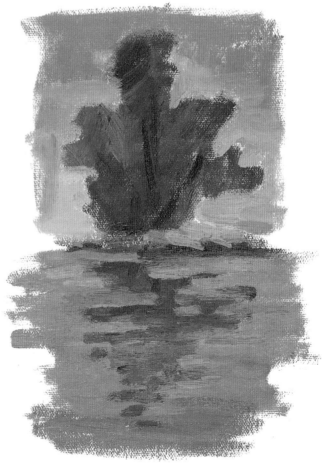

Reflection in rippled water.

Tall Trees and Reflections

The inspiration for this demonstration came from a small study I did while on location near Sun Valley, Idaho. Here is a photograph of the area to show you how very different the impression of a place is when you are actually painting on location from the impression in a photograph. I did not feel I was changing anything drastically—only responding to what was there and putting down the relationships between the color spots. I did do a bit of composing and simplification, but I could never have gotten the feeling of the finished painting from a photograph alone.

Step One

Draw in Shapes

I chose a vertical canvas to emphasize the tall trees and their reflections. Be careful not to divide the canvas in the middle because the trees are dominant and the reflections are only of secondary interest. Their purpose is to describe the fairly calm water. It's a good idea to do a few small, simple pencil sketches before you start on the canvas. The sketches give you an idea of where to place various objects. Two hours is the maximum amount of time you should spend on an outdoor study because of the changing light. From 9:00 A.M. to 11:00 A.M., or 2:00 P.M. to 4:00 P.M. are pretty good times, but every location has its own peculiarities. When you block in landscapes, you should draw straight lines whenever possible. This makes a stronger design. Landscape forms tend to get round and puffy soon enough.

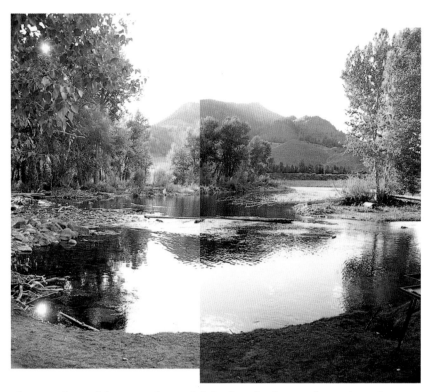

This is a photo of the area where I did the first sketch. I used two photos but, as you will see, the painting bears no resemblance to this photo.

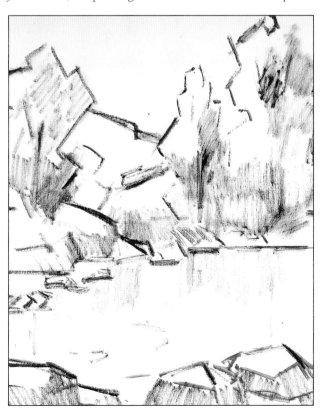

107

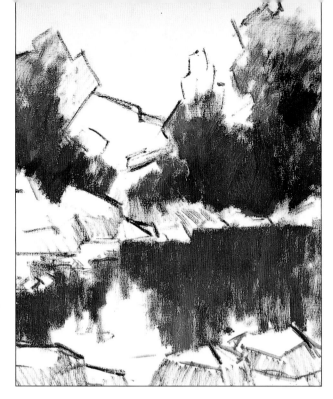

Step Two
Scrub in Darks

Scrub in the darks to begin the first stage of the painting process. Start with the trees since the reflections follow from the trees and are not as dark. Use vertical strokes for these dark areas. Reflections are not the exact color as the objects that cause them. The reflection tends to be warmer, perhaps greener or more orange. Use no white here. Experiment with various mixtures of black and orange, green, yellow and Burnt Sienna now. There are also a few touches of red and Alizarin.

Step Three
Cover the Canvas With Color

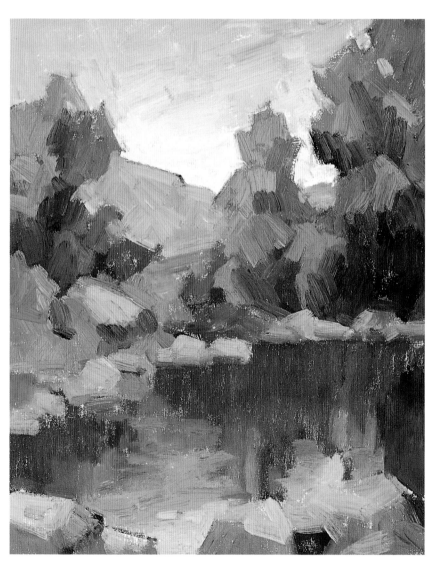

Continue the first stage by covering the canvas with spots of color, relating similar colors' values in order to make your judgments. This painting is a green-red harmony of fairly muted colors. The colors tend to look bright because we're viewing a landscape and don't expect to see pure colors. Muted colors, opposite each other on the color wheel, look more intense next to each other.

Keep the reflections of the sky on the water darker than the sky.

First, paint the sky at the horizon since the horizon is warmer than the zenith. Paint in a mixture of Cadmium Orange, Yellow Ochre and white. Add Cerulean Blue to the mixture on your palette, and place that above the first area. Gradually add Ultramarine Blue to areas above that, and blend in later. This gives you a luminous sky, full of light. If it doesn't work the first time, scrape and try again.

Step 4
Model the Form

Now is the time to make certain the color spots give a convincing impression of the time of day. Also, check the reflections, the varying distances and give volume to the rocks and trees.

Soften the areas where the lights meet the darks, such as in the water, some areas on the trees, in the shadows and where the mountain meets the sky. Blend the colors in the sky a little but not too much. Put in transition colors where light turns to shadow, and blend these areas.

The detail on this page gives you a pretty good idea of how few brush-strokes are actually needed to say "rocks, trees, water, cool afternoon."

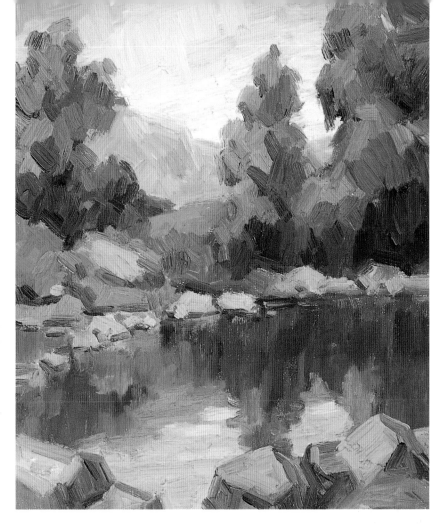

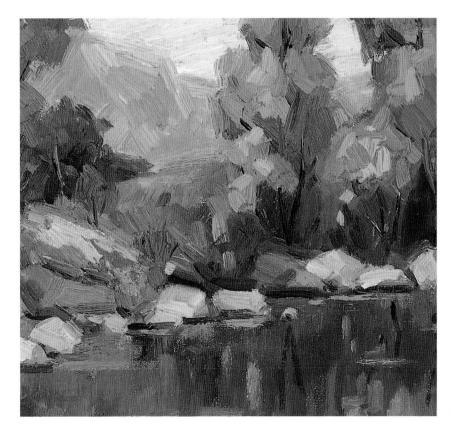

Detail.

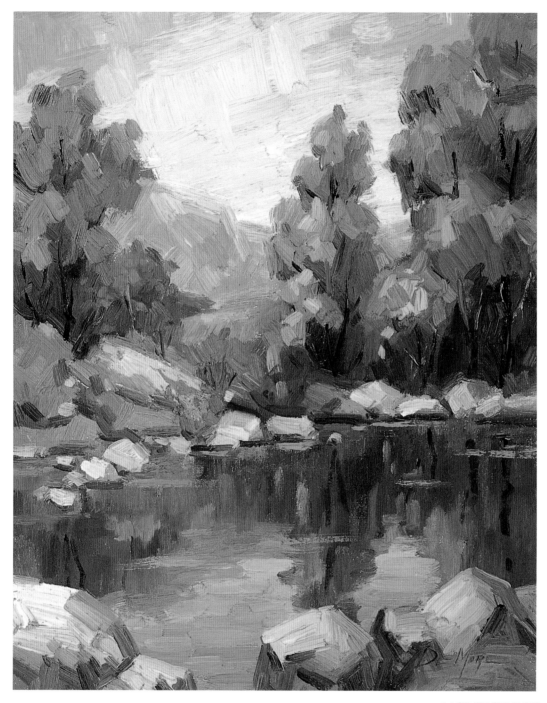

LAST OF SUMMER
20″ × 16″

Step Five

Details

For the final stage, put in the trunks to finish the trees. Add a few branches and a few leaves. In this painting, complete the upper part of the painting and the rocks first since the reflections must follow from the trees and sky. Then, suggest only a few dark trunks and a few light spots in the water. Remember to make these light spots darker than the objects they reflect and place them directly underneath their corresponding objects. Finally, place just a few horizontal cool strokes and make it say "water."

Paint Mountains, Rocks and Atmosphere

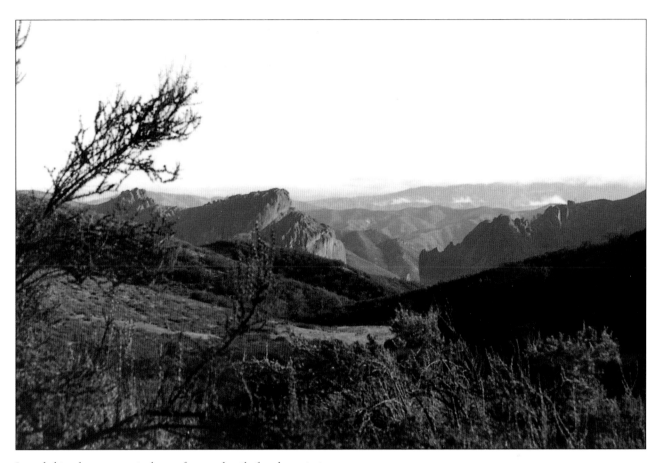

I used this photo to remind me of some details for the painting.

It is important to realize that any lesson on painting mountains, rocks and atmosphere really needs to be done within the context of the painting itself. This is true because portraying mountains and atmosphere has more to do with finding subtle color relationships than with "how to paint a . . ."

Remember to think of mountains as being shaped like cones, some rather smooth and some jagged with sharp edges. As mountains recede into the distance in a painting, they appear to be flatter, or to have less form. They also have softer edges and tend to be lighter and bluer.

The painting in this demonstration was inspired by a trip to the West Pinnacles on the central coast of California. I did a quick sketch at the foot of the trail and took some photos to remind me of some details. Then I started the hike up. And up. And up. Two days later, I was still in pain, but the scenery was worth it!

Step 1.

Step One
Paint in Shapes

When you design a painting like this one, pay attention to the shapes. Make sure they are interesting and of varied sizes. This even applies to the sky. Sometimes artists talk about positive and negative shapes; the positive shape refers to an object, and the negative shape refers to the background. The implication is that the negative shape is less important, but this is not true. On a canvas, every shape is always important and must be considered.

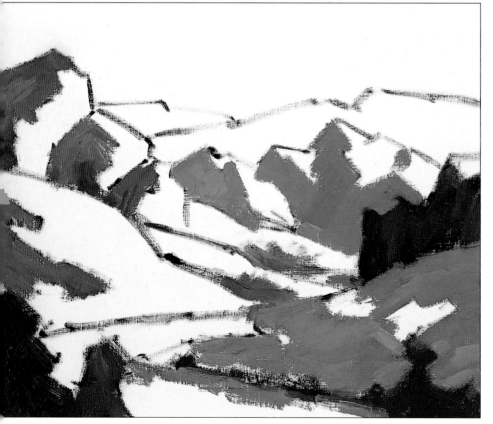

Step 2.

Step Two
Lay in Darks

Begin to cover the canvas in this first stage by laying in the dark areas, starting with the warmest, almost red-violet rock formation on the right. Add blues to the mixture on the palette for the formation on the left, the more distant shadows in the mountains and the shadow on the foreground hills. Scrub in dark warm colors in the bushes and bank of the road.

Step Three
Lay in Color

Continue the first stage by putting in the lighter areas, including the more distant mountains and the sky. Mix each color well so you can achieve the subtle color changes that give the illusion of the mountains receding into the distance. I can't describe the exact color mixtures for this painting because they are a result of mixing color into the pile of color already on the palette. Just keep trying and scraping and trying until your painting looks OK, even though it doesn't look exactly like mine. It never will. Even if I tried to copy one of my own paintings, it would never look exactly like the first one.

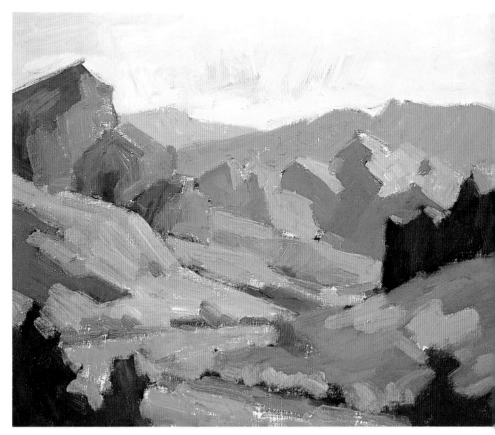

Step 3.

Step Four
Model the Form and Refine Color

Since the color relationships in this painting are so subtle, I found that I needed to continue making changes even as I put in some transition colors to model the forms in this middle stage. This was especially true on the formation on the left. I also decided to paint out the green spots of sunlight on the hill on the right so I could place the spots differently for a good design. I changed the shapes of some of the hills for this same reason. Remember, it is never too late to make changes in an oil painting!

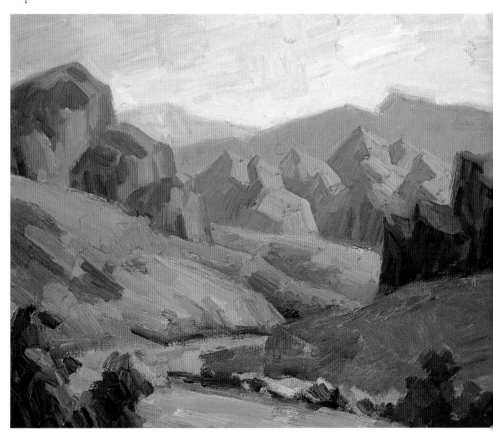

Step 4.

Detail

This detail shows the subtleties of the colors, as well as the brushwork. Notice the variety of edges on the hills and mountains, sharp on the rocks and blended on the rolling hills. Also, notice the cool blue stroke on the middle hill to make it recede and lie flat.

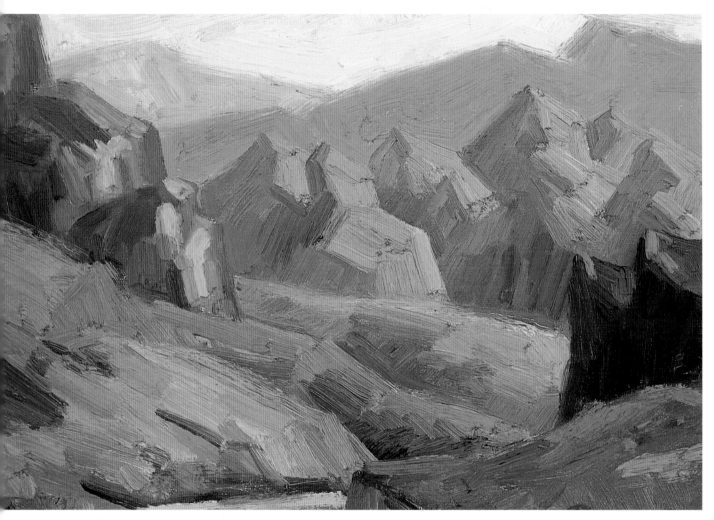

Detail.

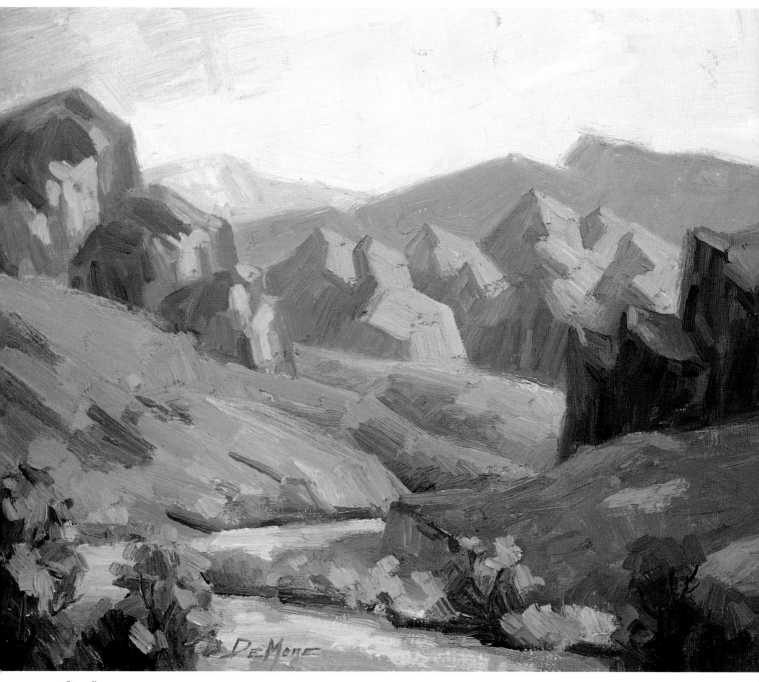

Step 5.

Step Five

Details

Now, place the highlights on the main formation, put in some leaves, branches, light areas on the road and any other accents that seem to be necessary to finish the painting. Use your intuition.

Stretch Your Color Sense

Now that you have done a few paintings, it's time to stretch a little. You will discover your own color sense as you continue to paint. Your color sense is different from anyone else's. Ten artists can work on the same subject and each will produce a different but "correct" painting. For this demonstration, I can give you only slight hints of the color mixtures because

► once you are into the painting, you will see that these subtle colors are obtained by adding small amounts of color into the puddle of color already on the palette
► as you know by now, you can arrive at any color in many different ways
► as you paint a color into a wet color on the canvas, it will appear different from anything you can mix on the palette
► it's more important to mix a color that's right for the painting you're working on than to mix a color that matches one in this or any book

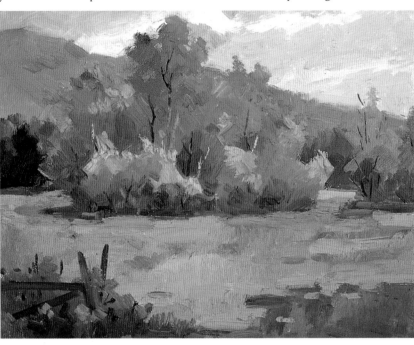

This is my first sketch of the scene.

Source

This demonstration was inspired by a trip to the Northwest in search of fall color. The photo doesn't do justice to the actual scene. My first sketch even pales in comparison to the one I did the next day when the sun came out and I warmed to the mood and became more sensitive to the colors.

This is a photo of the subject. Again, the photo doesn't begin to do justice to the actual scene.

Notice how this second sketch differs from my first. The sun came out, and I warmed to the mood.

Step One

Draw in Shapes

Begin as usual with the preliminaries of dividing the canvas into interesting shapes. Notice that the diagonal in the foreground, which indicates the road, opposes the strong diagonal of the mountains. The direction of the clouds also repeats this diagonal.

Step 1.

Step Two

Scrub in Darks

Scrub in the warm dark areas of the trees, using mixtures of Alizarin Crimson, Burnt Sienna and black to begin covering the canvas in this first stage of painting. For the background trees, try green and black with a little blue. The mountains are mostly blue, black and a little Alizarin Crimson and white, while the foreground shadow is the same with more Alizarin Crimson. The sky starts with a mixture of Cerulean Blue and white with more Ultramarine Blue and a little Alizarin Crimson added toward the zenith.

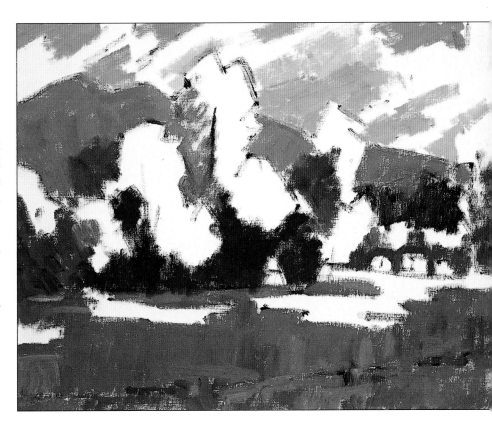

Step 2.

Step Three
Cover the Canvas With Color

Continue to cover the canvas with color spots to indicate the light areas and the clouds.

Step Four
Refine Color

In this middle stage, model the forms, refine color spots and place transition colors to suggest form. Add just a few strokes of slightly warmer red-violet to the background mountains to suggest the light side.

When I added richer, warmer colors in the sunstruck trees to give the foliage form, I felt it necessary to warm up the foreground shadow to better harmonize with the rest of the painting.

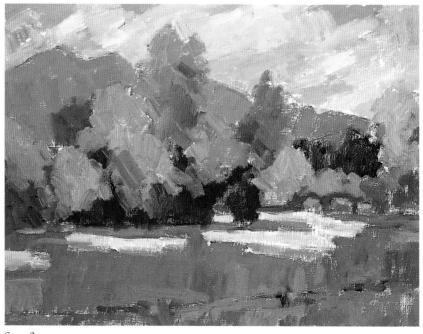

Step 3.

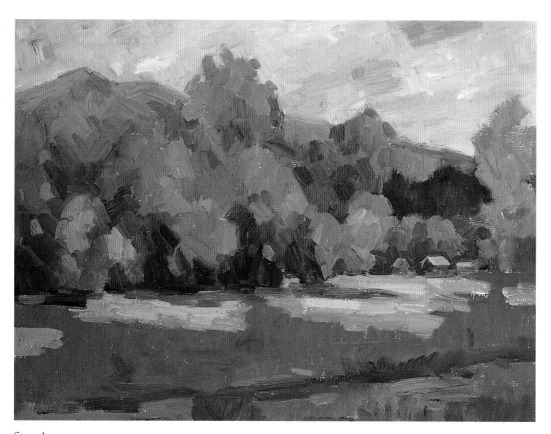

Step 4.

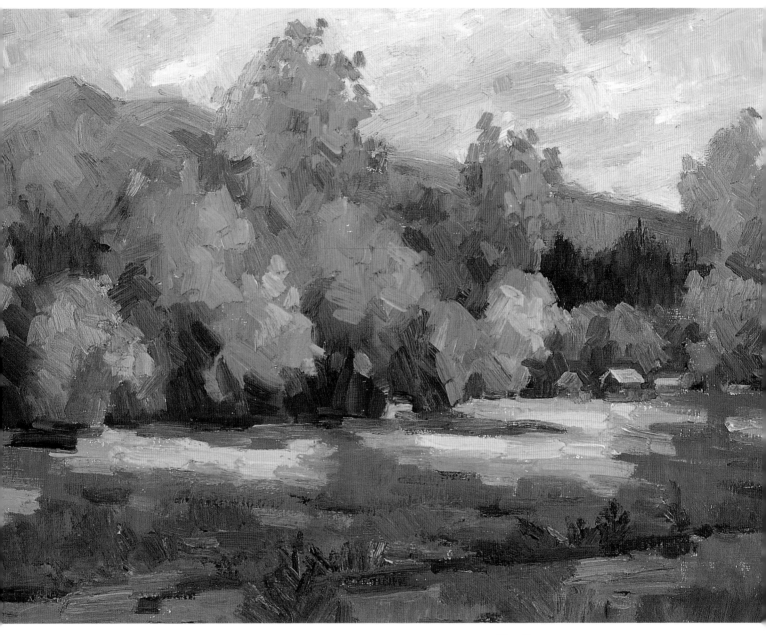

Step 5.

Step Five

Details

As you put in details for the final stage, the finish, work on the entire painting. This avoids too many details all over the painting. It's still not too late to make adjustments and it's much easier to do if you haven't put in the final twigs and branches.

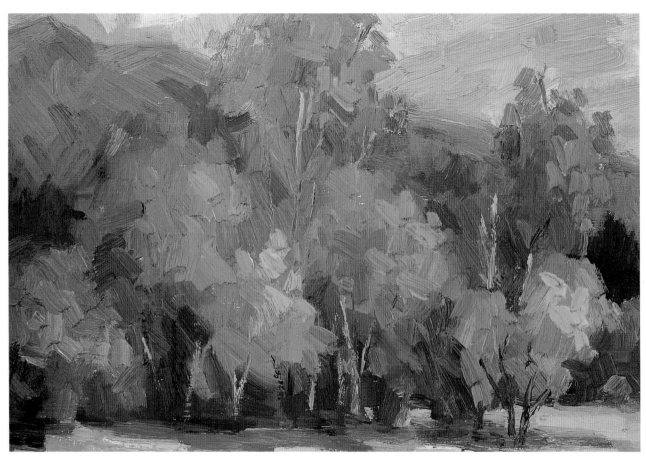

This detail shows how few branches are needed and how rough the brushwork is. It also shows various degrees of crisp, soft and lost edges.

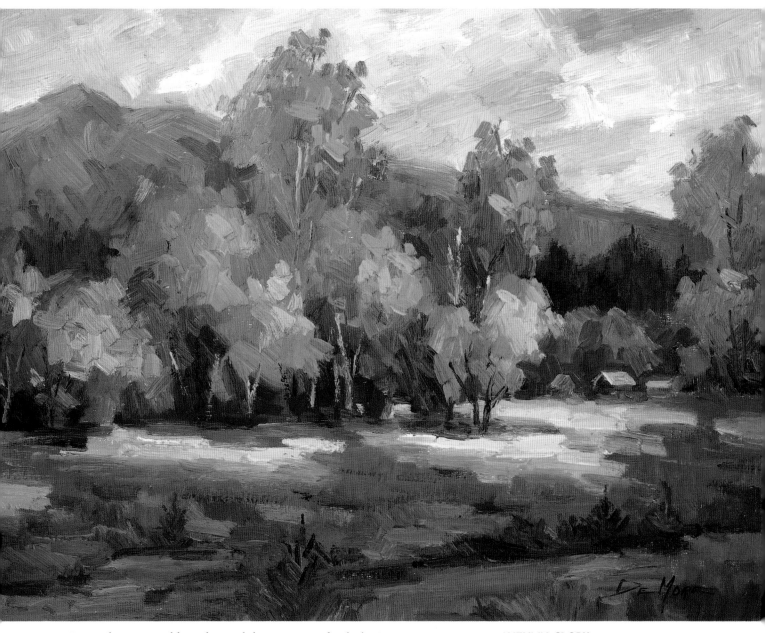

Put in the twigs and branches and the painting is finished. Now you can sign it. Need I say more?

AUTUMN GLORY
18″ × 24″

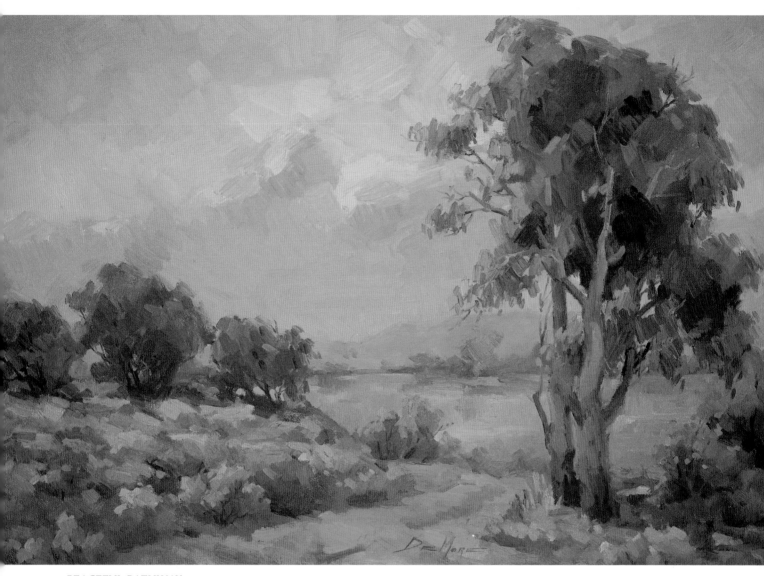

PEACEFUL PATHWAY
24″×36″

My Philosophy About Painting

I'd like to share with you my philosophy and some of the ideas I've learned or come to realize over the years I've been painting.

- ▶ Painting is easy; it's just a matter of putting the right color in the right spot.

- ▶ Don't worry about talent; it means nothing without perseverance.

- ▶ What you focus on expands. This applies to endeavors as well as flowers.

- ▶ In the beginning, you are developing good habits, not creating masterpieces.

- ▶ If you have some painting experience and have bad habits, resolve to change them today. You can continue the race with a flat tire, but you probably won't make the finish line.

- ▶ You could always watch TV and eat bonbons.

- ▶ Have fun playing with colors.

- ▶ There are no muddy colors, just misplaced color. You need muddy colors to make the brilliant ones sing.

- ▶ Use a bigger brush.

- ▶ Scrape more often.

- ▶ Use more paint.

- ▶ Keep it simple.

- ▶ Stand back.

- ▶ Squint.

- ▶ Make more mistakes.

- ▶ It's impossible to extract the truth from a lie. A photograph is a lie; the tree is the truth.

- ▶ Don't seek approval too soon. You will likely only receive criticism. If you do get approval, you will stay where you are.

- ▶ The creator builds; the critic destroys. The first is difficult; the second is easy.

- ▶ If you carry a painting too far, it's OK. You will learn more than if you stop too soon. You must ruin a few paintings to progress.

- ▶ If the desire is there, the gift is there.

- ▶ If you have the desire, you will be given the means. You may have to work for it, though.

Glossary

analogous Colors that are next to each other on the color wheel.

block in To paint areas as simple shapes of flat color.

center of interest The area the artist wants the viewer to give the most attention to.

color wheel A theoretical, orderly arrangement of the colors, which facilitates understanding of the color.

complementary Colors that are across from each other on the color wheel.

composition The artist's choice of objects or the subject for a painting.

cool colors Colors, such as blue, green and violet, that are associated with things that are cold, for example, ice and water.

cool light Light from the sky or fluorescent light.

design The way shapes and lines are arranged in a painting.

easel Support for canvas.

flat Used to describe areas that are painted simply, with no changes to suggest volume.

focal area Similar to center of interest, that is, where the artist wants the viewer to focus the most attention.

French easel A box with folding legs attached that holds supplies and canvas and is suitable for travel and outdoor painting.

glaze To apply a thin layer of paint that has been thinned with medium over a dry passage, allowing the color underneath to show through and produce a new color.

halftone A color between the light and shadow areas of an object. A transitional halftone where light meets shadow is used for modeling.

hue Basic character of a color. Hue is what most people think of when asked, "What color is it?"

intensity How rich or muted, bright or dull a color is. Another way of saying this is how "saturated" a color is. Example: a pure red is at full intensity and becomes red-brown as it becomes muted, or less intense, until finally, it loses all saturation and becomes gray.

key The dominant value range of a painting as in high key—light; middle key—medium; low key—dark. The key of a painting expresses a mood.

local color The color most people think is intrinsic to an object, as a red apple or green leaves.

medium 1. A liquid, such as linseed oil, used to thin paint and facilitate drying. 2. Material used to create art, such as oil paints or watercolors.

modeling the form To give the illusion of volume on the flat surface by changing value, color, intensity or temperature or by blending colors together.

negative shape The space surrounding an oject in a painting or background.

opaque Pigments that do not allow light to show through and, therefore, reflect light. Cadmium colors, Cerulean Blue and Titanium White tend to be opaque.

painting knife Similar to a palette knife but usually smaller and comes in many different shapes for applying paint.

palette 1. Surface on which to mix paint. 2. The choice of colors for a given painting.

palette knife Small spatula-shaped tool to mix and scrape paint on the palette.

positive shape The space defining an object or objects in a painting.

scrub To work a fairly thin amount of paint, which has not been thinned too much with oil, onto the canvas. This produces a rich foundation of color that won't interfere with successive layers of paint by becoming too oily.

shade Any pure color plus black.

sketch A drawing or painting done quickly to extract the essence or character of a subject for a later painting.

study A small painting or drawing done quickly to familiarize the artist with a subject.

tint Any pure color plus white.

tone Any pure color plus black and white.

transparent Pigments that allow light to show through, providing an airiness to very dark passages. The darker pigments, such as Alizarin Crimson, Phthalo Blue and French Ultramarine Blue, tend to be more transparent than lighter ones.

value How light or dark a color is, from black through gray to white.

warm Colors, such as red, yellow and orange, that are associated with warmth or remind us of warm temperatures, for example, the sun, fire and red-hot metal.

warm light Sunlight or incandescent light.

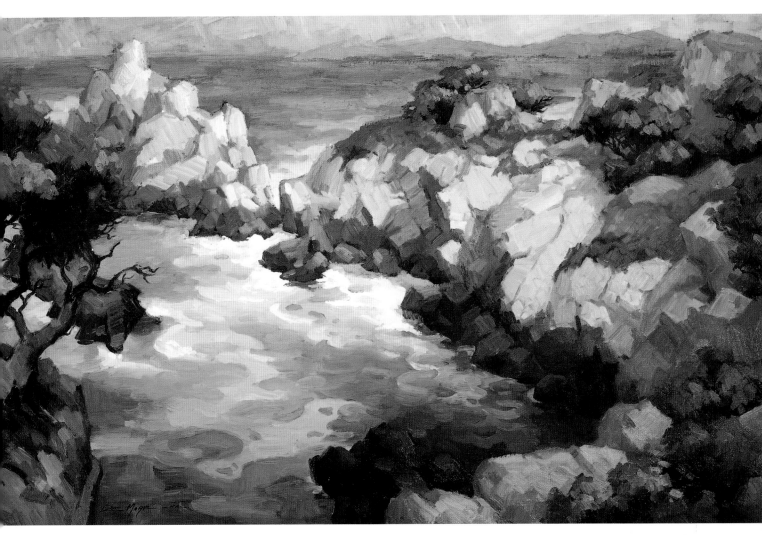

POINT LOBOS
30″×48″

Bibliography

When you first learn to paint, you have so many questions and there are even more answers. I kept this list of books fairly short so that the most important and pressing questions usually asked by beginners can be addressed first. I refer to these books over and over again. A few of these may be hard to locate, except in the library, but most of them are currently available, and some of them are even paperbacks.

I also recommend that you study the work of master painters, both in museums and in books. Some of the artists whose work I admire most are Joaquin Sorolla, John Singer Sargent, Nicholai Fechin, William Merritt Chase, Sergei Bongart, Valintin Serov, Isaak Levitan and Franz Bischoff.

Cameron, Julia. *The Artist's Way: A Spiritual Path to Higher Creativity.* New York: J.P. Tarcher/Perirgee, 1992.
An inspiring and uplifting book with exercises that really work to enhance your creativity. The author shows a great deal of empathy with artists.

Carlson, John. *Carlson's Guide to Landscape Painting.* New York: Dover, 1973.
A classic guide to landscape painting. This teacher's students include many accomplished painters.

De Reyna, Rudy. *How to Draw What You See.* New York: Watson-Guptill, 1972.
One of the best books on drawing for beginners that I've seen yet.

Edwards, Betty. *Drawing on the Right Side of the Brain.* Los Angeles: J.P. Tarcher, 1979.
A great book that has helped many students discover that drawing isn't so difficult after all.

Gruppe, Emile. *Gruppe on Painting.* New York: Watson-Guptill, 1976.
A "painterly" painter and teacher who painted directly and used delicious brushwork.

Hawthorne, Charles W. *Hawthorne on Painting.* New York: Dover, 1960.
A classic compilation of quotes from a master teacher that give further insight into how to see color.

Henri, Robert. *The Art Spirit.* New York: Harper and Row, 1984.
Another inspiring classic on the artistic interpretation of a subject.

Johnson, Cathy. *Sketching and Drawing.* Cincinnati: North Light Books, 1995.
Good ideas to get you into the habit of sketching, which is so necessary to your growth as an artist.

McCracken, Harold. *The Frank Tenney Johnson Book.* New York: Doubleday, 1974.
A member of the National Academy, this western painter is the one to study, especially his night and moonlit scenes.

Payne, Edgar. *Composition of Outdoor Painting.* Bellflower, Calif., DeRu's Fine Art Books, 1988.
Advice and examples from one of the great landscape painters of America. Worth studying and a treasure to own.

Peel, Edmund. *The Painter Joaquin Sorolla.* London: Philip Wilson, 1989.
The Spanish master painter of light, especially sunlight and shadow.

Ratcliff, Carter. *John Singer Sargent.* Abbeville Press, Inc., 1986.
The master of American impressionists. Design, color, drawing, technique—he had it all.

Sovek, Charles. *Oil Painting: Develop Your Natural Ability.* Cincinnati: North Light Books, 1991.
This artist shows excellent use of color applied with direct, elegant simplicity.

Stern, Jean. *The Paintings of Franz A. Bischoff.* Los Angeles: Petersen, 1980.
This catalog is a collection of his paintings that shows his incredible understanding of color.

Strisik, Paul. *Capturing Light in Oils.* Cincinnati: North Light Books, 1995.
A living National Academician whose paintings exhibit wonderful sensitivity and subtle design.

Webb, Frank. *Strengthen Your Paintings With Dynamic Composition.* Cincinnati: North Light Books, 1994.
When you crave answers to questions about design and composition, here they are—clearly illustrated and poetically described.

Index

Get the Best Art Instruction and Inspiration Available!

No Experience Required: Water-Soluble Oils—This book shows you how to immediately achieve amazing results with a paint that's easy to use, simple to clean, and safer than traditional oils. You'll find an introduction to water-soluable oil basics, lists of essential materials, instruction for using key brush techniques, as well as 12 skill-building exercises.
ISBN-13: 978-1-58180-608-3, ISBN-10: 1-58180-608-6, paperback, 112 pages, #33166

Land & Light Workshop: Capturing the Seasons in Oils—All artists can capture the stunning beauty of the seasons in oils with Tim Deibler at their side. You'll learn how to understand light and ultimately master the four keys to any successful painting—shape, value, color and edges.
ISBN-13: 978-1-58180-476-8, ISBN-10: 1-58180-476-8, hardcover, 128 pages, #32744

Land & Light Workshop: Painting Mood & Atmosphere in Oils—You too can master the art of landscape painting by using basic oil techniques to convey every scene with mood and feeling. With sections covering oil painting basics, brushwork techniques and 13 demonstrations incorporating a variety of subjects, this book is your guide to creating a technically sound painting while capturing emotion and creating evocative scenes.
ISBN-13: 978-58180-631-1, ISBN-10: 1-58180-631-0, hardcover, 128 pages, #33203

The Pencil Box—Almost all artists have room for improvement when it comes to drawing—the fundamental skill of all realistic art. *The Pencil Box* covers dozens of drawing techniques, addresses the most common stumbling blocks, and gives solid easy-to-follow advice for improvement, so you'll find everything you need to start drawing better in one comprehensive package. Features 14 step-by-step demonstrations.
ISBN-13: 978-1-58180-729-5, ISBN-10: 1-58180-729-5, paperback, 128 pages, #33403